Pl₍

S₍
ple₍

Ren₍
Enq₍
Mini

L32

Roger Cardinal

PRIMITIVE PAINTERS

With 40 colour plates

THAMES AND HUDSON · LONDON

First published in the UK in 1978 by
Thames and Hudson Ltd, London

© Blacker Calmann Cooper Ltd, 1978
This book was designed and produced by
Blacker Calmann Cooper Ltd, London

Filmset by Southern Positives & Negatives (SPAN), Lingfield, Surrey
Printed in Spain by Heraclio Fournier, S.A.

Introduction

CREATIVE ART IS NOT CONFINED TO PROFESSIONAL CIRCLES. One of the most striking examples of an upsurge of artistic creativity outside the normal spheres of recognition is neo-primitive or naive art. This book is an attempt to define and to illustrate this phenomenon, which, because its very nature is so resistant to conventional modes of critical understanding, is still only imperfectly defined and appreciated. It is because naive art is in a sense 'illegitimate' — not entered on the official register of acceptable art within our culture — that it has attached to itself a reputation of inadequacy and is often seen as a pathetic aberration, or at best a trivial curiosity. But it is time to discard such received ideas and to look honestly at neo-primitive art for what it is — an entirely admirable mode of creation, something made by individuals for other individuals to share, and hence as deserving of our consideration as any of the recommended offerings of subsidized academic art.

The irritating factor of confusion in this regard has always been that our language is resistant to the task of defining novel experiences in terms which are positive in both form and spirit. The word 'naive', for instance, has connotations of incompetence and dull-wittedness, or the word 'primitive' those of anachronism, which at once suggest that 'naive painting' or 'modern primitive art' must be unworthy of serious attention. But I would argue that one can be a 'naive' without being an idiot, and a 'primitive' without renouncing one's modernity, and that in the final analysis the issue is not whether the neo-primitive is 'up to date' or 'respectable', but whether he is genuinely expressive — that is: whether his work speaks to us meaningfully and powerfully, irrespective of considerations of time and fashion.

It is actually not so difficult to grasp what is meant by terms like 'naive art' or 'modern primitives', once we show the good-will to face this sort of art on its own terms and to think positively. All the same, it is true that the question of terminology has traditionally haunted all approaches to the subject. The range of critical terms includes 'naive painting' (Wilhelm Uhde, Jacques Guenne, Anatole Jakovsky and others), 'primitive painting' (Jean Lipman), 'modern primitives' (Robert Goldwater, Oto Bihalji-Merin), and 'primal artists' (Vladimir Maleković), and the list could be extended almost indefinitely — grass-roots artists, autodidacts, marginal artists, the irregulars of art, and so forth. I shall in these pages make use of more than one variant. Broadly speaking, though, the outline of a definition is already apparent. We are talking about artists who go back to primary sources for their inspiration. They work from instinct and communicate a view of reality whose freshness and popular appeal are guaranteed by their independence of the conventions laid down by the academic elite.

Now that our basic conception of the neo-primitive is becoming clear, I would like to eliminate some of the remaining confusions which have led to an erroneous assimilation of naive art to other, more or less contiguous types of art. The first of these is 'folk art' as understood in Europe — that is: a peasant tradition based on inherited motifs and styles, an art of the community at large rather than of any isolated individual. Here one may cite the folk arts of Rumania or of Switzerland, which manifest themselves in a host of forms, from paintings on houses and furniture to ornate costumes

and decorated utensils. Here 'art' is more akin to 'craft' in so far as it is anonymous, derivative and almost entirely subject to conventional patterns. (It should be noted that in the United States the term 'folk art' has been used rather differently and refers to any form of art flourishing outside established academic circles.) The second type is 'primitive art' in the sense of tribal art produced by non-European peoples. The colourful carpets woven by the nomadic Baluchi tribes of north-east Iran, the wooden figures made by the Dogon of Mali, the bark-paintings of the Australian aborigines, the intricate stylized carvings of the Haida people of British Columbia — these are all examples of art-forms which, for all their exotic differentness to European art, in fact emerge from a collective culture in which genuine singularity of style and spontaneous departure from tradition are unthinkable. Moreover, both folk art and primitive art tend to be functional and decorative, whereas naive art is usually non-utilitarian and representational.

The equivalent of these collective art-forms in modern societies such as Britain and the United States is 'popular art', admittedly a very loose category, which may be taken to cover all the vernacular traditions, more or less ephemeral, which have given rise to such varied artifacts as signboards, storefront adornments, pub-signs, restaurant frescoes, fairground and circus banners, figureheads on ships, carved toys, gravestones, quilts, pavement drawings and the like. (Several sub-genres are already being delimited within this vast general area: tramp art, needle art, graffiti, tattoo designs, and so on.) Again the point is that, while made by people impervious to the rule and example of 'high' art, these artifacts tend to conform to a standard model and are rarely the result of a singular, distinct artistic vision. The anonymity of the artist is the natural corollary.

There should be no cause to confuse the term 'modern primitive' with the term 'primitive' as applied to pioneers in a cultural tradition, such as the Italian 'primitive' painters Cimabue, Giotto and Sassetta, though stylistic analogies might be instructive. A closer cousin to naive art is 'child art', but whereas the latter may be deemed innocent of formal influence and expressive of an uncultured (if underdeveloped) vision, it is rarely individual in its stamp, and certainly much less powerful in expression. Then there is the fairly obvious distinction to be drawn between the genuine naive and the 'Sunday painter' in the sense of the dilettante whose work is intended as an addition to or a reflection of the academic canon, and thus lacks the spontaneity and total engagement with the inventive process which characterize neo-primitive art proper.

We now come to the final distinction in this series, after which the field of naive art should be fairly well circumscribed. The last category is that of *Art Brut* or 'outsider art'. The definition of *Art Brut* was established by Jean Dubuffet in the 1940s and may be summarized as encompassing these criteria: the artist shall be innocent of pictorial influences, and perfectly untutored; he shall be socially non-conformist, even to the point of diverging violently from the psychological norm (some of the most impressive items in Dubuffet's collection are the work of lunatics); and he shall not cater for a public. Now the naive artist diverges from this model in several respects. He is often well integrated within his own culture (albeit a *popular* culture rather than an elitist one). While the typical outsider artist retreats into an obscure private idiom that defies comprehension, the naive painter feels that his pictures should mean something to others, and likes to see them on show. All in all, he is not an outsider, a dissident, but a self-assured individual in touch with his milieu.

Despite these provisions, it is a matter for dispute at present whether one can reliably classify certain artists whose work falls close to the line separating these two types of untutored, individualistic art. In normal circumstances, the distinction is clear: it would be ridiculous to claim any kinship between the magic realism of the neo-primitive Ernst Damitz (*plate 6*) and the flamboyant unrealism of the psychotic artist Adolf Wölfli. But borderline cases are not uncommon; there is Séraphine Louis, one of a cluster of French naives discovered by Wilhelm Uhde and thenceforth always bracketed with names like Rousseau and Bombois. Despite this classification, her flower paintings often exhibit an obsessional intensity which I feel reflects a trance-like absorption in the creative process such as to place her art a long way beyond the operations of straightforward, communicative picture-making. Such images, I suggest, could well qualify as *Art Brut* (*see plate 18*). The distinction — which cannot be supported by any objective findings — must rest on the observer's response. Where one senses the artist turning away into an incisively private world, the work can be seen as *Art Brut*. Where the work reveals an individual temperament and makes use of idiosyncratic means, yet still recognizably appeals to an audience, then the artist should be seen as a modern primitive.

It should further be pointed out that the typical naive maintains an acceptable sense of the collective world. He does not retreat from everyday life; he does not hate other people, and even welcomes their interest in his art. Yet he is like the outsider artist in one important respect: his reluctance to participate in official culture. He is not the professional artist who will chase after dealers and seek to publicize himself and his work in whatever way he can. His pleasure in art has no hint of commercialism about it. Creation means infinitely more to him than being trendy, and he may even be indifferent to success if it does arise. Thus Alfred Wallis (*plates 36, 37*) was able to work for many years in St Ives without his native spontaneity and independent vision being at all impaired by the interest shown in his work by establishment artists such as Ben Nicholson. There are, of course, cases where the naive does fall prey to commercial seductions, and hence loses his authentic touch. Some of the gaps in the documentation of naive art in this volume may be explained in terms of this standpoint. I take André Bauchant and Dominique Peyronnet, for instance, to be cases of self-taught painters who turned into established gallery artists of international repute: their professional knowingness places them on a level with painters like L. S. Lowry, a trained artist who cultivated a consciously 'naive' style.

We have seen that one of the crucial criteria for naive art is that it should be the product of an untutored eye and hand. It comes to us direct, not mediated by any acquired notions of how things should be transmitted pictorially or how paint should be handled to effect. The naive takes up his brush and sets to work regardless. He follows no rules. He makes no preliminary sketches. He ignores scale and traditional academic perspective. He applies colour in an unnaturalistic way, sometimes direct from the tube. His human figures are unmodelled and wooden. His spatial sense tends to flatness, and his landscapes are rigid and reminiscent of painted stage-sets.

All these characteristics demonstrate one important point: that the naive is heedless of the codes of representation which are integral to 'high' or academic art. This raises the question of how we are to proceed to an appropriate response to neo-primitive work. Those who admire Goya's *Naked Maja* will find Rousseau's nude (*plate 28*) implausible; while the landscapes of Poussin have a poise and symmetry altogether missing in Thomas Chambers' painting of *Niagara Falls* (*plate 5*), which has the feel of a card-

board cut-out. The buildings of Emerik Feješ (*plate 8*) bear only a superficial resemblance to the models from which he ostensibly worked. And some people would say that Joe Sleep's *Cat* (*plate 35*) is nothing like a cat.

However, it is quite simply inappropriate (and even silly) to go to naive art in expectation of a competence in a language which the artist simply does not speak. The example of great classical paintings, the principle of naturalistic representation — such traditional points of reference continue to haunt us, but are strictly irrelevant to our understanding of the naive idiom. The logic of the primitive lies in his adoption of his own code, his own frame of reference. He paints what he feels, in a way which makes sense by his own lights. The result is that he does not so much trace the appearance of reality as transcribe a personal reading of reality through a system of equivalents, in a kind of flat pictorial handwriting whereby, for instance, unmodelled frontal views of people and buildings are considered an adequate signal of their physical presence. These figures are stiff, heraldic. They are not the things themselves, nor their appearance, but they *denote* them.

Our approach to naive painting must be to place ourselves in a posture receptive to the simple directness of this pictorial language. To apprehend Rousseau's nude, we must forget the sophisticated sensuousness of Goya and allow our eyes to accustom themselves to less 'realistic' shapes whose impact is rather different — more cerebral in fact. Chambers' landscape is not a bloodless exercise in aesthetic geometry, but a vital transmission of his involvement in the majesty and immensity of a natural phenomenon, and we should try to tune in to his feelings rather than hold back and complain that his technique is faulty. Feješ's church and Sleep's cat are similar cases. We do not come to these images to gain insights into geographical, architectural or zoological actualities. Instead we witness a *way of seeing* and a *mode of expression* which are undoctored and immediate, and which finally speak to us of temperament and vision rather than of the object itself.

Now it is often the case that the neo-primitives claim that their work is in fact a faithful copy of a shared external reality. They often choose to depict homespun scenes that they have known all their lives, chronicling events they have witnessed, as if seeing themselves as historians of their local culture. It was in such a spirit that Joseph Pickett catalogued his rural world for posterity (*plate 21*) and that the anonymous author of *Death of McPherson before Atlanta* (*plate 2*) made a pictorial memento of an event in the collective experience, in a manner which seems to be saying to us, 'this event really happened, and this is a true record'. Yet for all these avowals of a realistic intent, for all these appeals to a collective agreement about what the world is like, naive painting generally resists assimilation to our actual commonplace perception of the world. The realism here is a mental realism, or in the words of Vladimir Maleković, 'not the reflection of reality but rather the reflection of the idea of reality'. What the naive paints is not the thing itself, but its imprint on his consciousness.

This explains one of the odd things about naive art, that we can often see it as both scrupulously dedicated to detail and oddly at variance with our normal experience of the way the world looks. Lefranc's view of the Eiffel Tower (*plate 17*) has an almost uncanny aura about it, for despite the faithful notation of the minutiae of brickwork, stone and metal, the total effect of the painting is curiously remote and not really reminiscent of any actual view of the Paris landmark. When the naive invests each square inch of his canvas with an equal intensity, imparting meaningfulness to the slightest detail, he ends up creating — despite himself, even — an impression of halluci-

natory sharpness. Paradoxically, devotion to 'the facts' results in a kind of visual shimmer which transfigures the reality depicted. What seems basically familiar will then be bathed in a miraculous luminosity and take on the appearance of a crystalline, otherworldly utopia. The translucency of Steve Harley's version of *Wallowa Lake* (*plate 11*) is so electrifying that we no longer feel we are looking at a factual record of a place. The painting has become a window onto a higher reality, the ecstatic space of an enhanced consciousness. In this perspective, it is not hard to appreciate the strategies of the contemporary Yugoslav naives Ivan Rabuzin (*plates 23, 24*) and Matija Skurjeni (*30–32*), who are applying themselves to the task of summoning forth non-objective realities, putting the pictorial language of primitivism in the service of individual vision in its most extreme and phantasmagorical form.

Given the principles I have sketched above, it will be evident that no single manner can be identified as common to all modern primitives. There is no 'naive style' as such. All the same, there are instances where individuality is comparatively unstressed, and a survey of early American primitives reveals a gamut of types, from totally derivative (and by now deservedly anonymous) limner-portraitists whose pictures were knocked off with stereotyped deftness and a minimum of imaginative investment, to inventive artists whose names may have gone lost, but whose works bear a distinctly personal stamp, as witness the striking nineteenth-century *Cat* (*plate 1*). Elsewhere, a kind of corporate style has evolved among certain naives, in a way which must be seen as the result of mutual influence — in other words, of a *tradition*. Thus the group of naive painters centred on the Yugoslav village of Hlebine is a 'school' which, having launched several artists of the calibre of Ivan Generalić (*plates 9, 10*), has in recent years begun to produce a rather slick and gimmicky style, indicative of a received dexterity rather than genuine creativity. The tendency to slickness is most lamentably exhibited in contemporary France, where the business of sponsoring naive art has been a going concern ever since the avant-garde took up 'Le Douanier Rousseau' at the turn of the century. The Paris art market has firmly established *art naïf* as a highly saleable product, and an army of neat, regimented painters has sprung into action to produce an art-form for the bourgeois sitting-room as indistinguishable from industrial conformism as Toby jugs and wallpaper.

It is surely clear that primitivism need not imply aesthetic inarticulacy, and that the painters we call naive do not all turn out decorative, pretty-pretty pictures. If coy kitsch and quaintness are features of the least distinctive naive work (at which point it would be more accurate to speak of popular art), I hope that this book will show that, at their best, the neo-primitives are capable of communicating an original vision of considerable power, and that the medium which communicates this vision may be said to have an appropriateness and even a sophistication all of its own. To allow ourselves to submit to that vision is not therefore to be taken in by a phoney surrogate of art: although it constitutes a special case, naive art is still *art*, and the experience it offers is ultimately one which transcends the limits of critical categories. When all is said and done, it is to the *images* that we must turn, their irreducible vitality reminding us that theory can never replace the pure experience of discovery.

ANONYMOUS (Nineteenth-century American)

1. *The Cat*

Mid-nineteenth century. Oil

In his desire to stress the power of the cat, this artist
vastly exaggerated the head, and then decided that the
depiction of the body was redundant. The dead bird in
the cat's jaws means that, for the time being, the birds at
either side may perch close to the predator with
impunity. An odd ambivalence results: the cat is
fearsome but also somewhat jovial, and the mood of the
picture seems at once cruel and droll. In general the
image has a heraldic simplicity reminiscent of a
signboard, say for a hotel. Rather than the record of a
specific drama, it is a stylized, mythical emblem.

*Washington DC, Collection Edgar William & Bernice
Chrysler Garbisch*

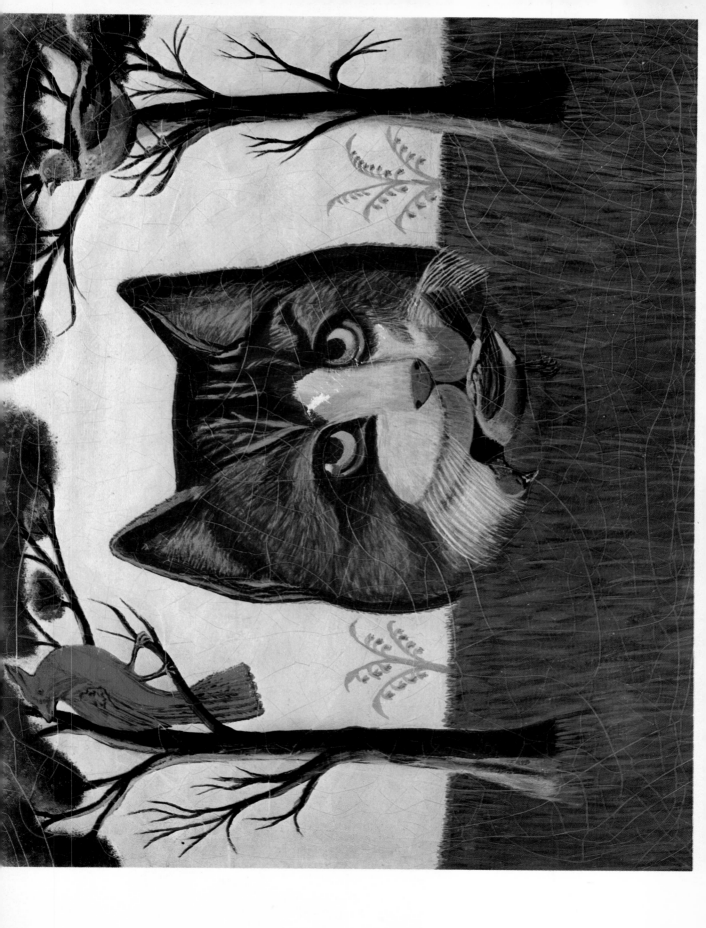

ANONYMOUS (Nineteenth-century American)

2. *Death of McPherson before Atlanta*

c.1864. Oil on mattress ticking. 28 ×42in (71 ×107cm)

From behind a clump of bushes a sniper's rifle flashes. The horse rears as the unsuspecting victim is hit and thrown woodenly back in the saddle, limbs jerking and hat flying off. The historic death of the Union General, James B. McPherson, at the battle of Atlanta on 22 July 1864 is given theatrical emphasis in the over-literal accentuation of the powder-flash and the exaggeration of the mightiness of the horse. We are being given the graphic demonstration that no human power can guard against the sudden intervention of Fate.

Philadelphia, David David Inc.

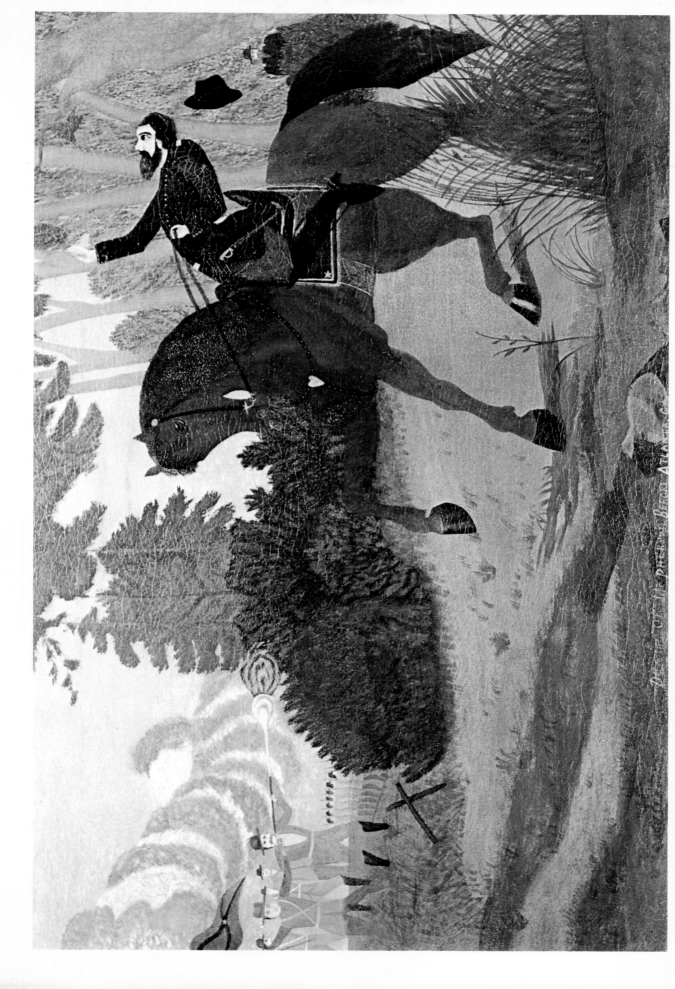

FRANZ BECK (Nineteenth-century American)

3. *The Council Fire*

c.1850. Oil on canvas. 62 × 88in (157·5 × 223·5cm)

This work by the American primitive Franz Beck
(probably a recent immigrant from Europe) reflects the
early stereotype of the Red Indian as a noble savage of
impassive mien who sported a spectacular headdress
at camp-fire pow-wows. But if it is unrealistic, the
painting has emotional and pictorial coherence. The
central glow of the flaming fire seems to expand into the
rest of the picture, emphasizing the dancing feathers and
bright clothing of the natives, and tinting the jagged
branches of the surrounding trees. An equation is being
drawn between the colour red and the sense of the
exotic, the savage. The flames may have connotations
of warmth or of menace.

Philadelphia, David David Inc.

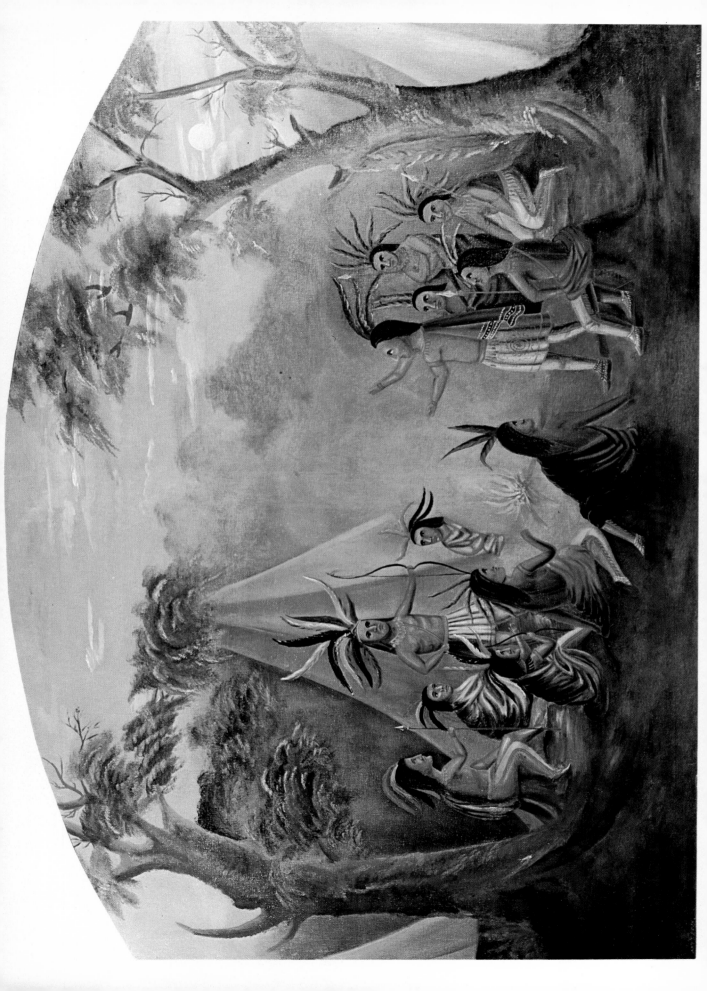

CAMILLE BOMBOIS (1883–1970)

4. *Wrestlers in the Camp*

c.1926. Oil on canvas. $23\frac{1}{2} \times 36\frac{1}{4}$in ($59\cdot5 \times 92cm$)

Bombois emerged in the late 1920s as one of the first naives in France to achieve commercial success. He had worked at such jobs as farm labourer, navvy, fairground strongman and printer's assistant before settling to painting full time. If his manner became progressively more assured and 'professional', his subject matter remained robust and down to earth. This picture records a memory of the infantryman's life during the First World War.

New York, Perls Galleries

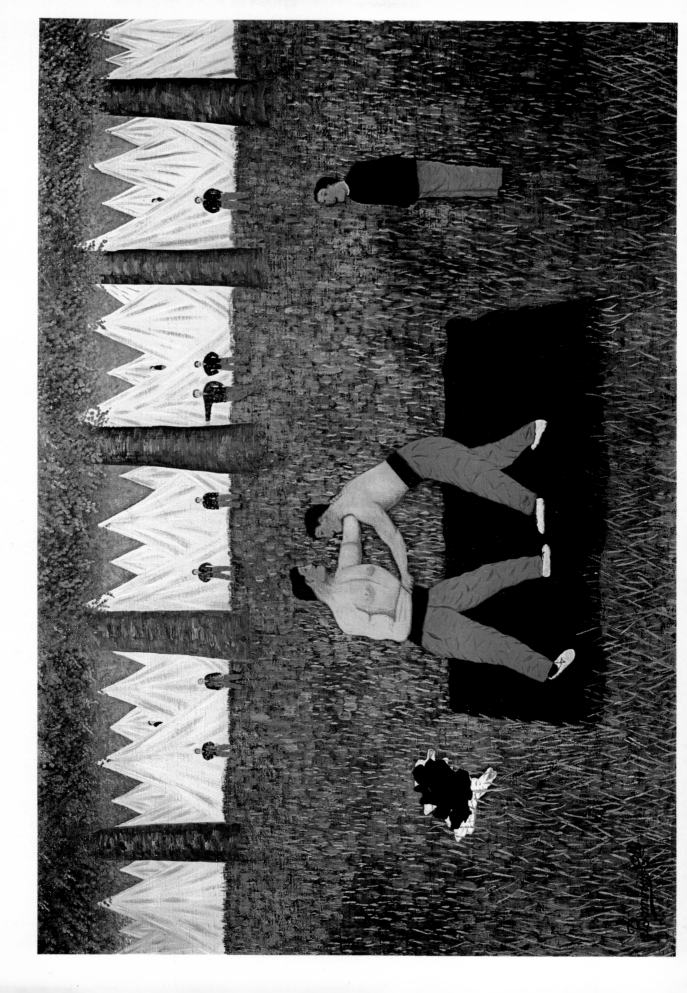

THOMAS CHAMBERS (c.1800–after 1855)

5. *Niagara Falls*

c.1850. Oil

Thomas Chambers was a landscape painter living in New York State in the last century. On a journey west, he recorded this vivid impression of Niagara Falls, portraying himself as a tiny foreground figure silhouetted against banks of cloud-like spray so as to point up the overwhelming size of the Falls. The dramatization of space results from this contrastive device in conjunction with an apparent accumulation of horizons: the eye is led upwards from man to foam, to river, to rocks, to falls, to distant houses, as if climbing up steps which the artist had added on one by one.

Hartford, Connecticut, Wadsworth Atheneum (Ella Gallup Sumner and Mary Catlin Sumner Collection)

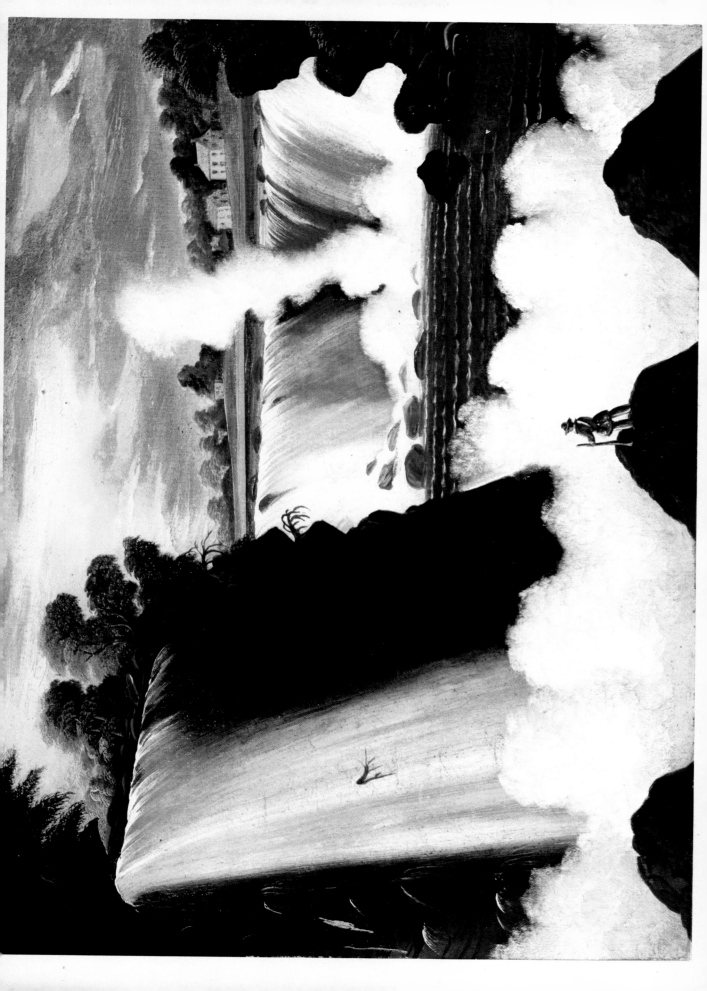

ERNST DAMITZ (1805–1883)

6. *Bayard Taylor's Midnight Sun in Lapland, Norway, Europe*

c.1870–1880. Watercolour. $9\frac{1}{4} \times 15\frac{1}{4}$in ($23 \cdot 5 \times 39 \cdot 3$cm)

Of aristocratic Prussian stock, Ernst Damitz emigrated to the New World in 1847 to settle as a farmer in Illinois. At around the age of 55, he turned the running of his farm over to his son and devoted himself to painting, producing exquisite watercolours based on his readings of popular travel books. This painting pays homage to the American traveller Bayard Taylor, whose accounts of exotic journeys to distant parts delighted the artist. Damitz had never set foot in Lapland, and his version of that ill-defined place is a bizarre assemblage of 'typical' features: craggy rocks, Lapp tents, reindeer, a Norwegian stave church. The picture exhibits some flagrant disproportions of scale and contrasts of finish (the sea is textured and turbulent, while the church is rigidly monochrome), and yet achieves a queer radiance entirely appropriate to the poetic subject of the nocturnal sun.

Chicago, Art Institute

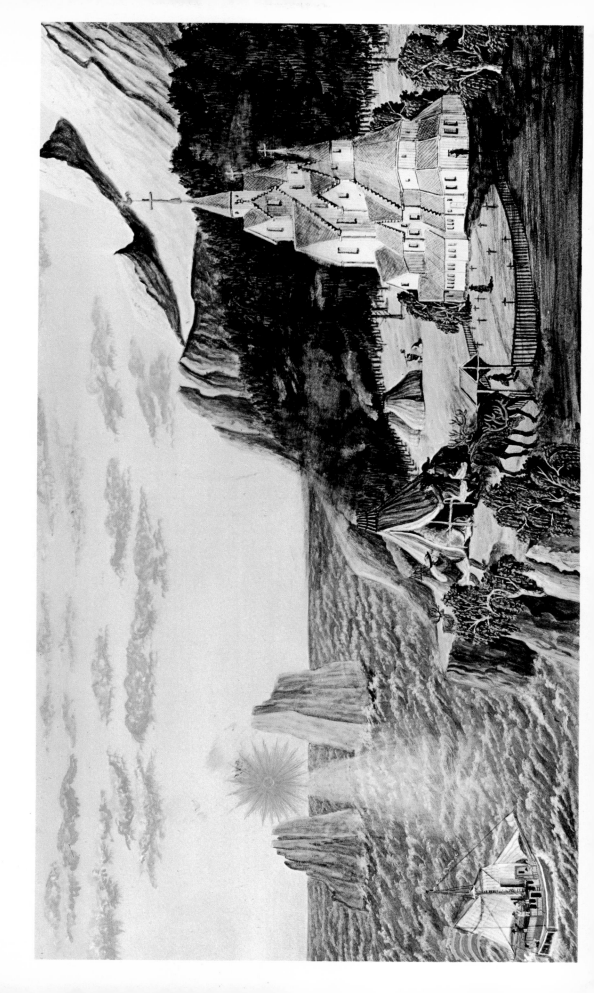

ADOLF DIETRICH (1877–1957)

7. *Girl with Striped Apron*

1923. Oil on cardboard. 14½ × 11in (37 × 28cm)

A self-taught Swiss artist, Dietrich has a dry, undramatic style verging on naturalism. In this portrait, the naiveté of the flat body and doll-like face is upstaged by the 'professional' finish to the hair.

Zürich, Kunsthaus

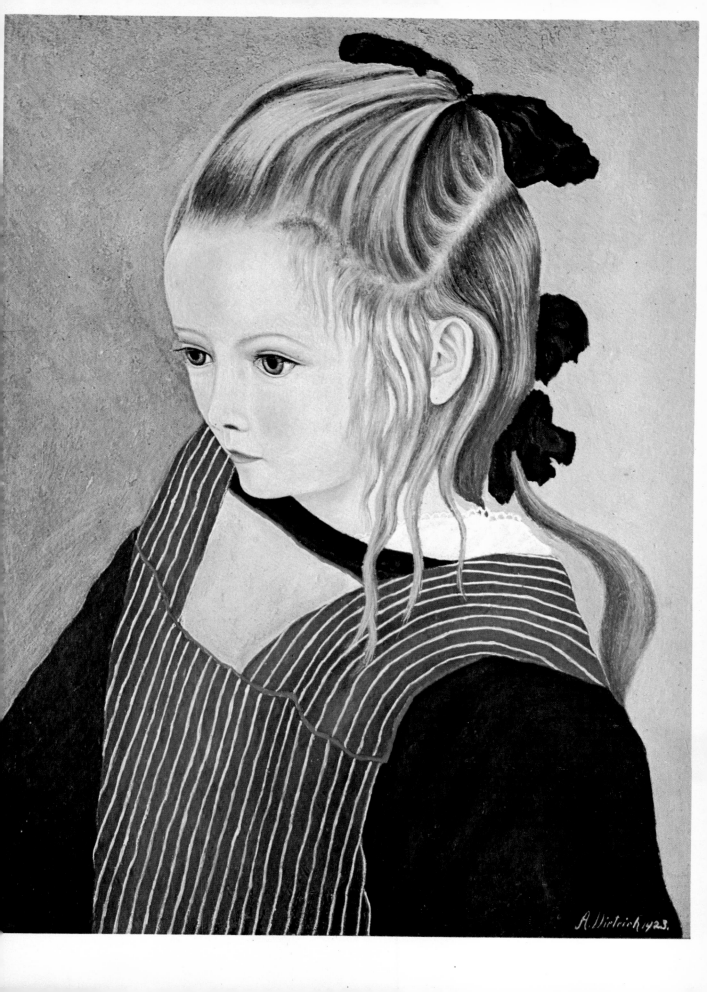

EMERIK FEJEŠ (1909–1964)

8. *Milan Cathedral*

1966. Tempera on canvas. 24¾ × 18in (62·5 × 45·5cm)

The paintings of the Yugoslav neo-primitive Emerik
Feješ constitute an album of visits to famous places. But
if his point of departure is a postcard of an actual
location, the artist's preferred mode of travel is the
imagination, and his theatrical buildings create an
environment in which there are no jostling crowds, no
noisy traffic to distract him from an almost voluptuous
immersion in sheer colour.

Zagreb, Gallery of Primitive Art

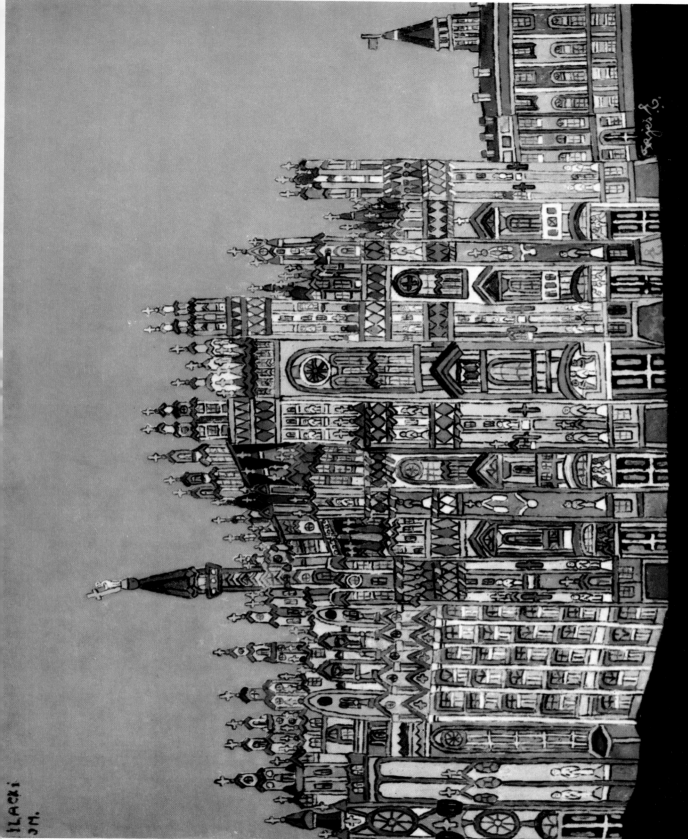

IVAN GENERALIĆ (b.1914)

9. *The Crucified Rooster*

1964. Oil on glass. $39\frac{1}{2} \times 33$in (100 × 84cm)

Ivan Generalić is the most famous of the Yugoslav naives, and his rise influenced a whole generation of peasant painters. Born in the Croatian village of Hlebine, he began drawing in his teens and has largely managed to preserve an independent idiom, although he was taken up for a time by the Zagreb artist Krsto Hegedušić, who taught him the technique of *Hinterglasmalerei*. The method of applying paint to the glass from the back implies an emphasis on surface detail and was particularly appropriate to Generalić's concern with the concrete realities of rural life. But, as this image shows, an investment in surfaces can produce a highly-charged emotional effect.

Zagreb, Gallery of Primitive Art

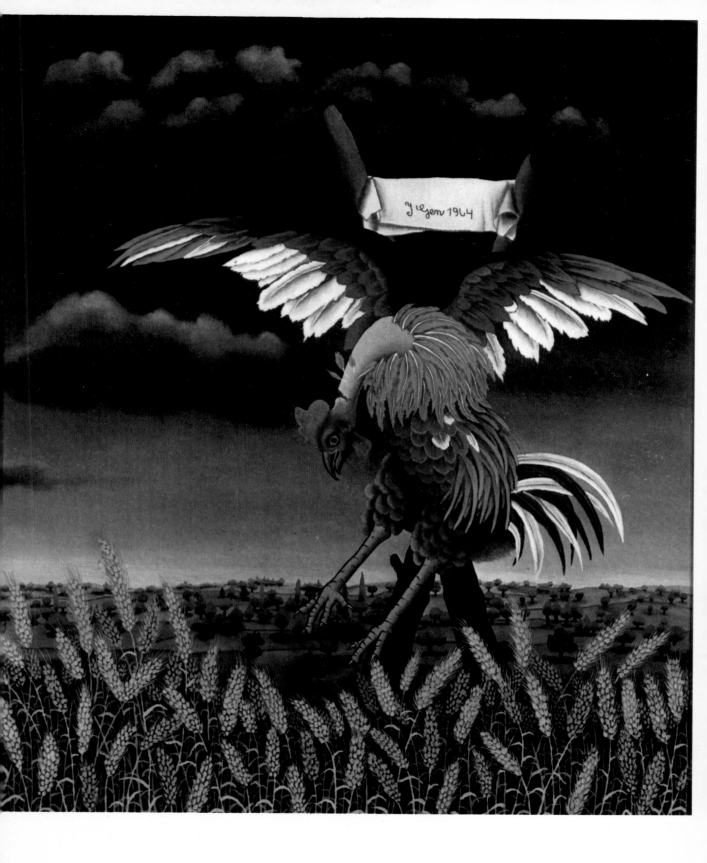

IVAN GENERALIĆ (b.1914)

10. *The Wedding of the Deer*

1959. Oil on glass. $19\frac{3}{4} \times 15\frac{3}{4}$in (50 ×40cm)

In much of his mature work, Generalić has explored an idealized vision of the world, creating a distinctive mythology of fantastic creatures such as white stags and unicorns, which haunt the boundaries of the peasant community. Here we glimpse stags hovering before a typically 'fantasticated' forest, the fragile embodiment of another, pristine reality.

Zagreb, Collection Josip Generalić

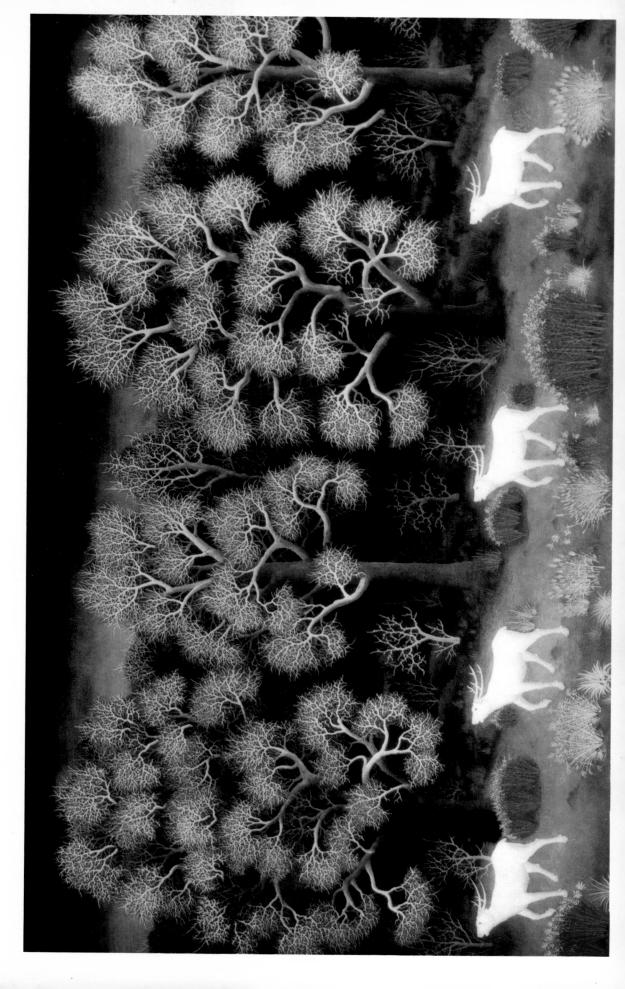

STEVE HARLEY (1863–1947)

11. *Wallowa Lake*

Oil on canvas. 8 × 10in (20 × 25·8cm)

Steve Harley was a Michigan farmer who experienced an overwhelming passion for the wild beauty of untouched nature on his journeys through the American North-West. This landscape induces a marvellous feeling of floating euphoria. The eye coasts in over the immediate ground, skims the glassy surface of the water and glides up the majestic slopes on the far shore: it is as though one were being gently tipped forward, then backward, transported between various vantage points in space so that every last detail of the scene is brought into fine focus. The pivot of the picture is the hovering eagle: shaped almost symmetrically around a vertical axis, it also counter-balances its double on the lake surface, where reflection creates a horizontal symmetry. In this painting, Harley achieves a supremely confident union of vibrant detail and overall pattern.

Williamsburg, Virginia, Abby Aldrich Rockefeller Folk Art Collection

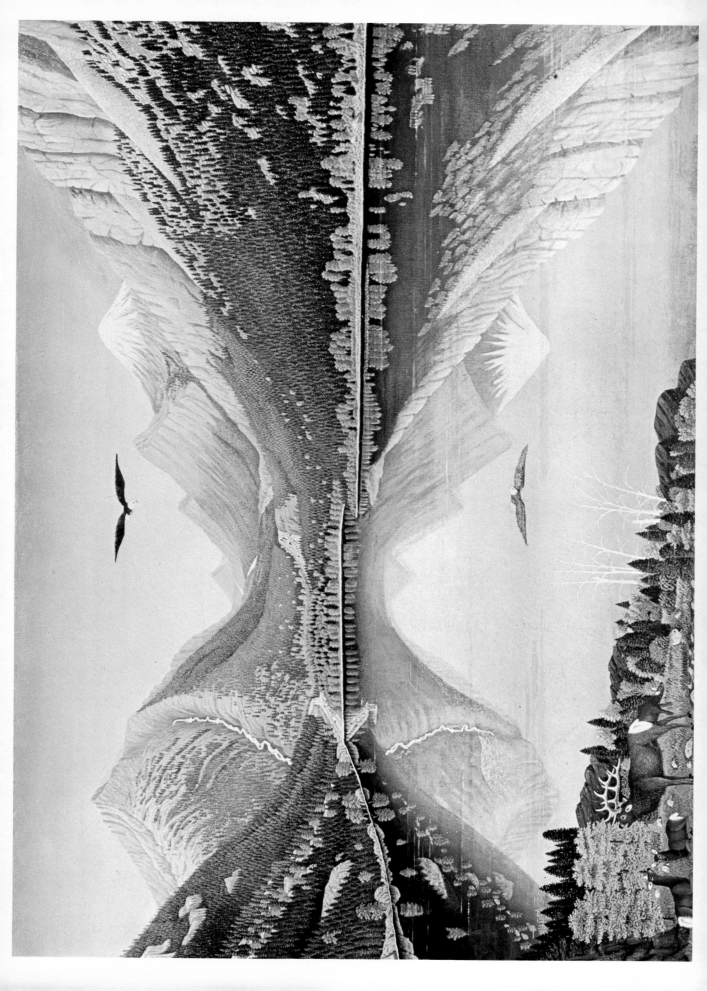

EDWARD HICKS (1780–1849)

12. *The Peaceable Kingdom*

c.1835. Oil

One of the outstanding primitives of nineteenth-century
America, Hicks was a Quaker minister who travelled
widely across the United States. His favourite theme was
the Biblical 'Peaceable Kingdom' in which the wolf
dwells with the lamb, the leopard lies down with the
kid, the lion eats straw with the ox, and so on. This is
one of several versions in which the utopian message is
consolidated by the insertion in the background of
another favourite story of resolved conflict: the Quaker
William Penn signing the treaty with the Indians. The
picture combines Biblical and historical elements with no
sense of incongruity, and nothing jars its fairytale
harmony.

*Williamsburg, Virginia, Abby Aldrich Rockefeller Folk Art
Collection*

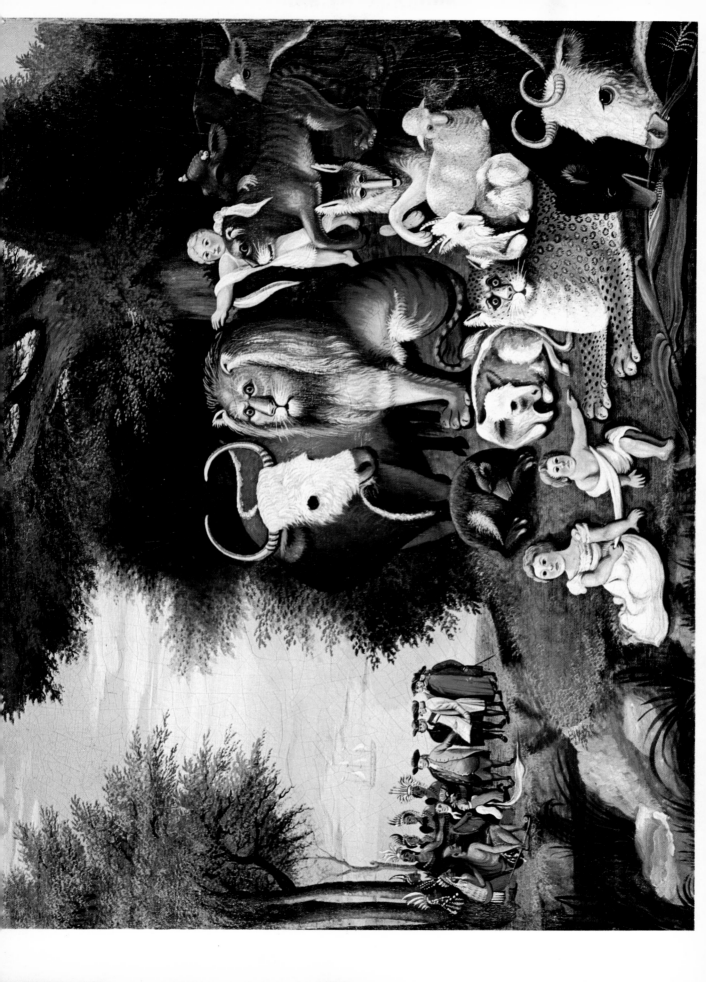

MORRIS HIRSHFIELD (1872–1946)

13. *Girl with Pigeons*

1942. Oil on canvas. 30 ×40in (76 ×101·5cm)

Hirshfield emigrated to the United States from Poland in his teens, and ran a business with his brother for years before starting to paint on his retirement at the age of 65. His images distil poignant erotic longings in the form of stylized female figures, often naked and accompanied by their familiars – cats, lions, birds – and set against a starry background. Flattened and simplified, these representations form an emblematic code which transmits a low-key, almost abstract message of idealism and adoration.

New York, Museum of Modern Art (Sidney and Harriet Janis Collection)

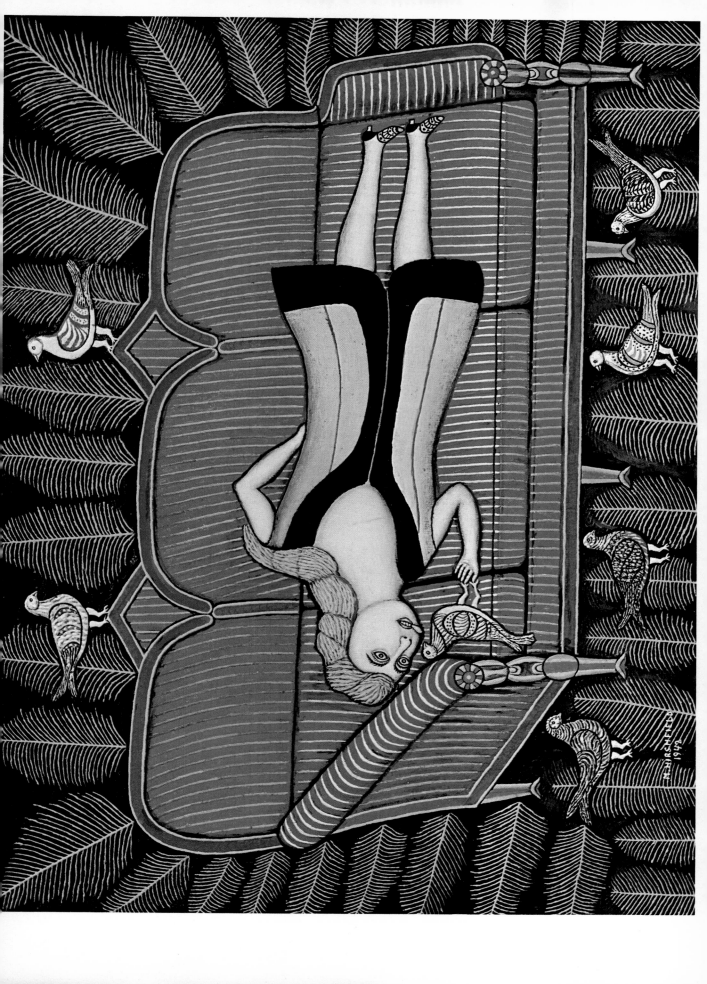

MORRIS HIRSHFIELD (1872–1946)

14. *Girl with Dog*

1943. Oil on canvas. $35\frac{1}{2} \times 45in$ (90 × 115·5cm)

This image is reminiscent of the story of the Beauty and
the Beast, with its underlying theme of the amorous
association of unlike creatures. Here the beast is a huge
heraldic dog whose teeth are bared in a fierce snarl yet
whose immaculate fur and tiny feet speak of docility and
refinement. The girl holding the leash is a defenceless
and innocent creature, and she floats above the ground
as if weightless. The pair belong together in a way which
Hirshfield does not spell out, and they stare at us
enigmatically.

New York, Collection Edward A. Bragaline

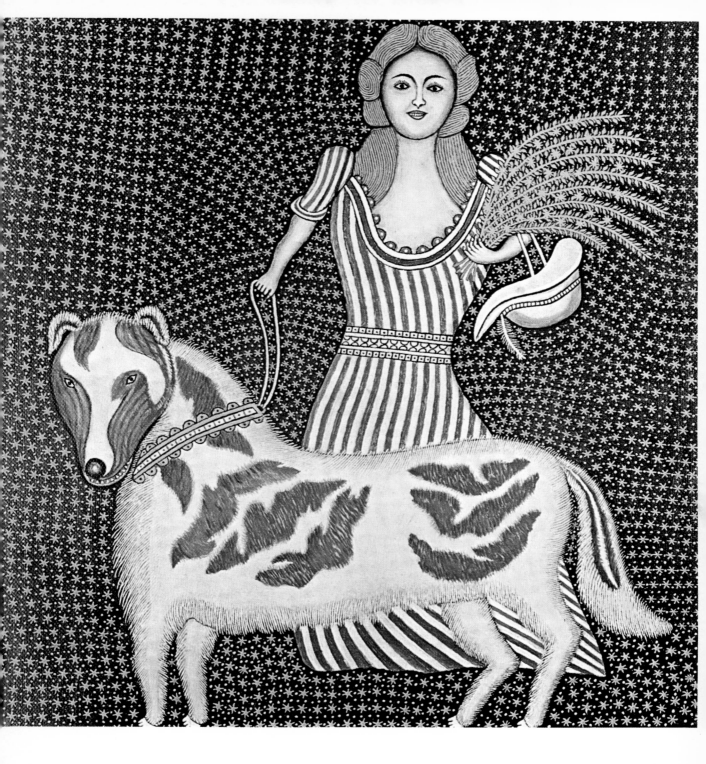

JOHN KANE (1870–1934)

15. *Self-Portrait*

1929. Oil on composition board. $36\frac{1}{2} \times 27\frac{1}{8}$in (92·5 ×69cm)

John Kane emigrated from Scotland to the United States at the age of 19 and led a tough itinerant life, working on the railroad and in mines and steel mills and later as a house painter and freight-car painter. He was a keen amateur boxer and this proud self-portrait proclaims his physical resilience, though the veined arm, lean rib-cage and tense throat muscles indicate an unflinching analysis of the marks of a harsh working life. This autodidact's probing accuracy edges towards a culturally recognizable naturalism.

New York, Museum of Modern Art (Abby Aldrich Rockefeller Fund)

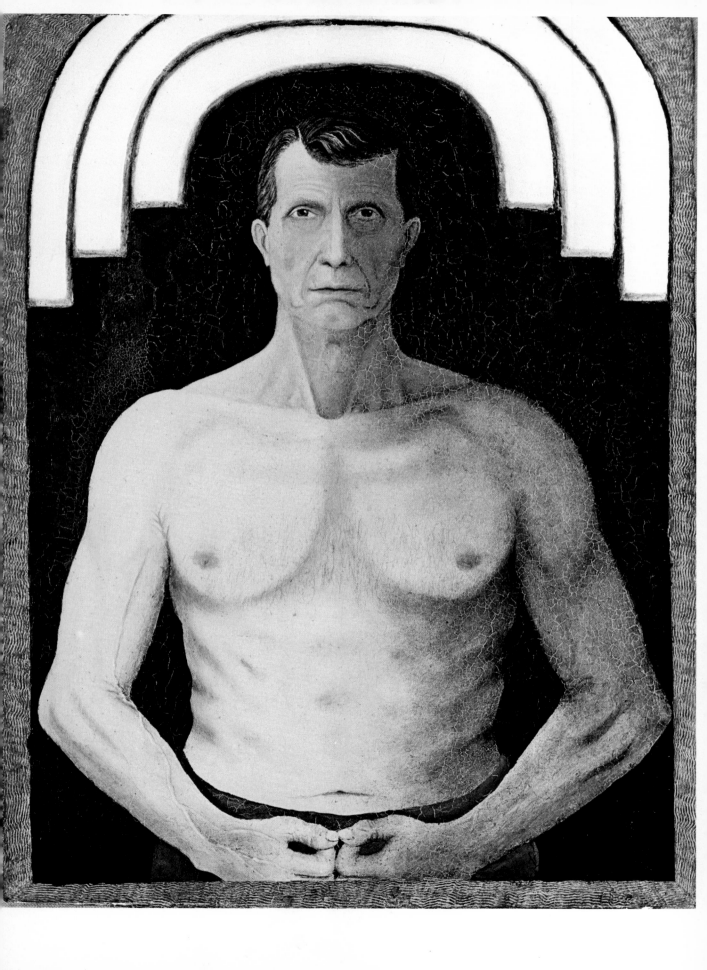

HENRY DEVALCOURT KIP (Nineteenth-century American)

16. *Attack by Bears*

Oil on canvas. 25 × 33in (63·5 × 84cm)

Any painter who depicts violence is faced with the discrepancy between the intended effect of dramatic movement and the ultimately static nature of paint. This American primitive seems prepared to draw attention to the discrepancy, portraying a terrifying situation in a totally rigid manner — a kind of pictorial antiphrasis. The acute colour stresses appear to be symbolic: the fallen man and his erect wife are vivid white, in contrast to the sombre bears, while the focal point is the brightly-attired Red Indian, the Hero of the Hour.

Bath, The American Museum in Britain

JULES LEFRANC (1887–1972)

17. *The Eiffel Tower*

Oil

Lefranc is a typical example of the French naive
dedicated to his environment, in this case Paris. The
city-scape is scrupulously transcribed, with a geometric
precision that impresses a kind of steely varnish onto the
city's haphazard layout and uneven edges. The effect is
of reality wiped clean and tightened up, the restoration
of the world to the cogency and unreal neatness of a
scale model.

Paris, Centre National d'Art et de Culture Georges Pompidou

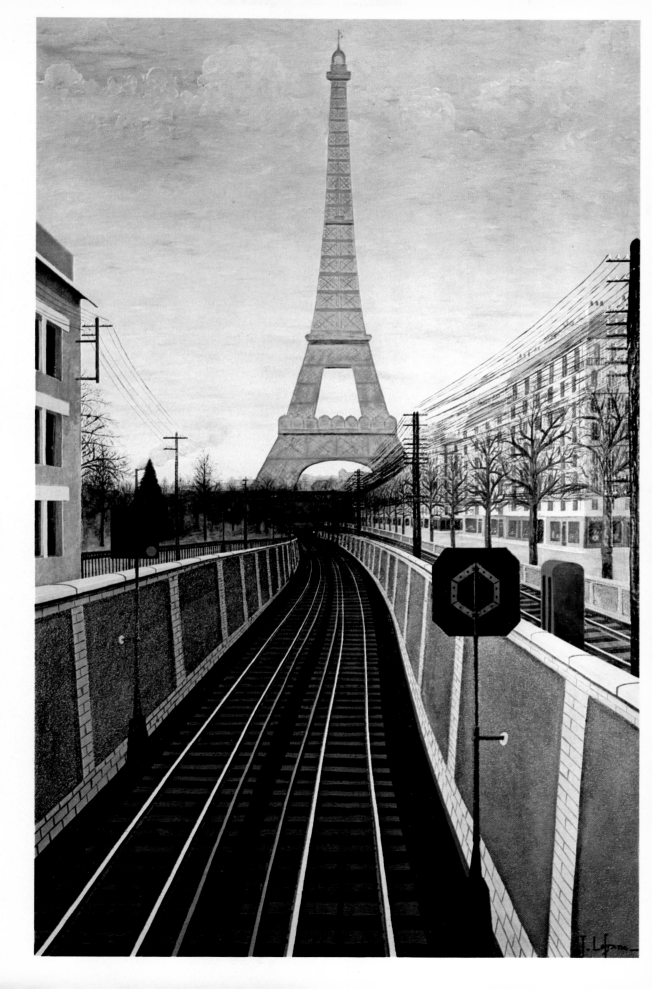

SÉRAPHINE LOUIS (1864–1942)

18. *The Tree of Paradise*

c.1929. Oil on canvas. $77\frac{1}{2} \times 52\frac{1}{2}$in (195 ×129cm)

Séraphine Louis was a humble cleaning-woman who
worked all her life in the French cathedral town of
Senlis. Religious fervour prompted dozens of remarkable
oil paintings which she sometimes explained as visions
relayed by her guardian angel. Her sole subject is flowers
and leafy plants, but her passionate style transforms the
conventional decorative motif into a pulsating symbol
of her inner life. This explosive tree, with its multicoloured
leaves that seem to flicker restlessly like feathers or
flames and its oracular staring eye, has a delirious
buoyancy that suggests an intense form of mystical, or
possibly even erotic, rapture.

Paris, Centre National d'Art et de Culture Georges Pompidou

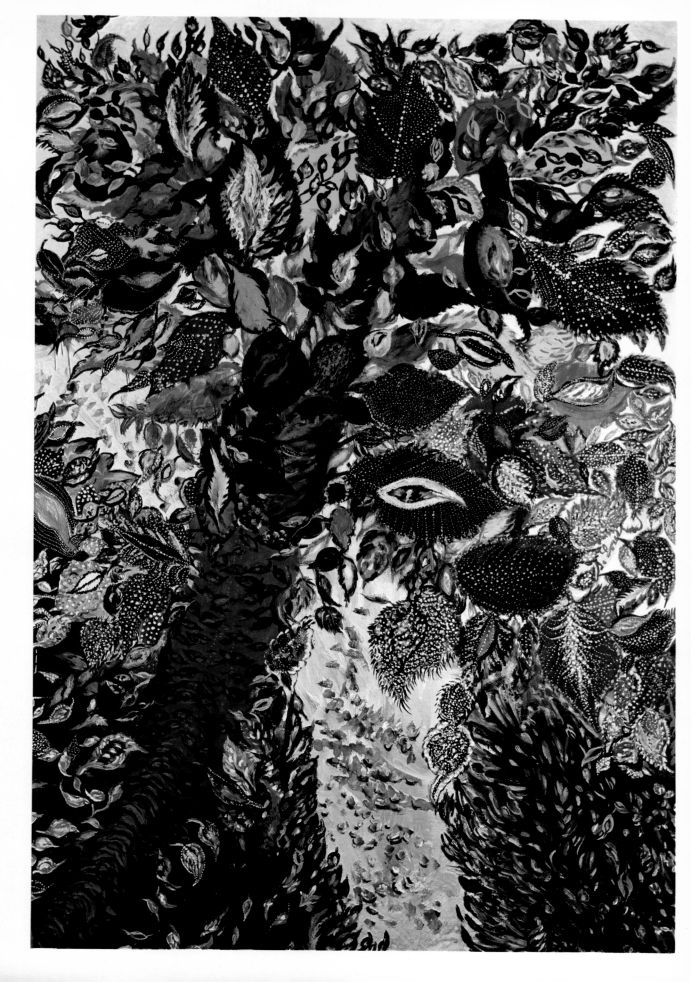

HARVEY McINNES (b.1904)

19. *Foothill Country*

*c.1974. Pastel and pencil on paper. 12 ×16in
(30·5 ×40·5cm)*

The Canadian neo-primitive, Harvey McInnes, has a
deep feeling for the place he lives in. Here the foothills of
Saskatchewan are the subject of an idyllic 'portrait'. But
is it entirely the place which is being portrayed? The
disposition of isolated rocks and trees, the blasted stumps
and the two deer whose antlers point up a whole series
of jagged shapes spread rhythmically across the picture —
these give an impression of being ciphers of a private
meaning which is perhaps not so idyllic.

Regina, Saskatchewan, D. & V. Thauberger Collection

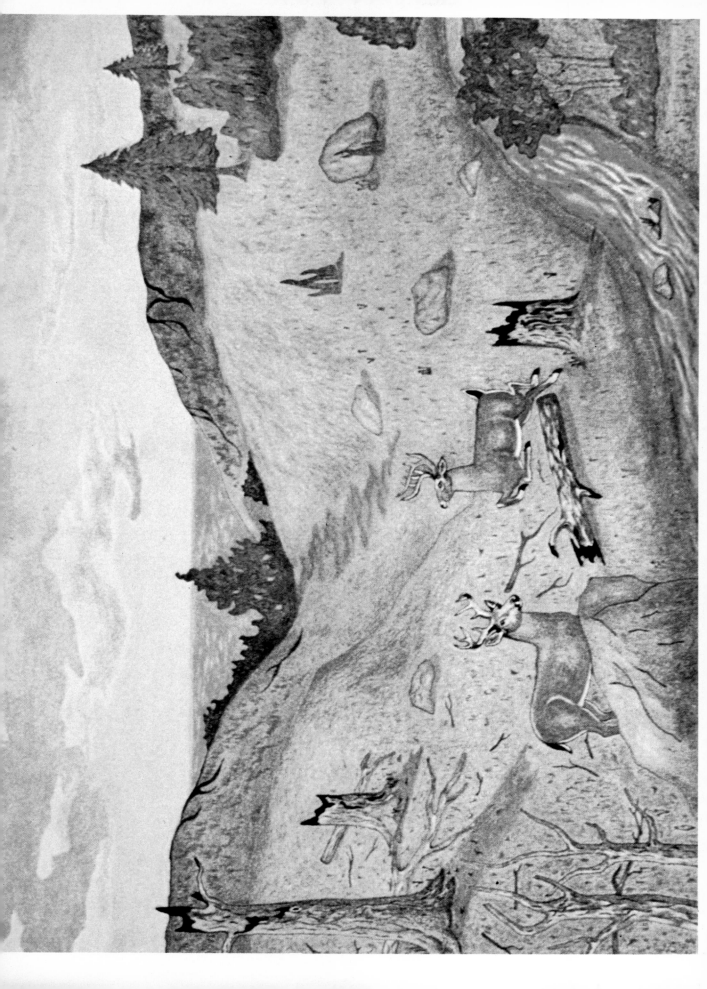

NIKIFOR (1893–1968)

20. *Nikifor on his Way*

1939. Watercolour. $14\frac{1}{2} \times 9$in (37 × 23cm)

The artist was an illiterate deaf-mute who scraped a
living as a pedlar hawking his pictures around the
mountain villages of southern Poland. His paintings
were made with pitifully improvised materials and are
annotated with lettering which the artist could not
himself understand. A perfect example of creativity
unchannelled by official culture, Nikifor's work has
directness and boldness of touch, and transmits the
flavour of an independent spirit.

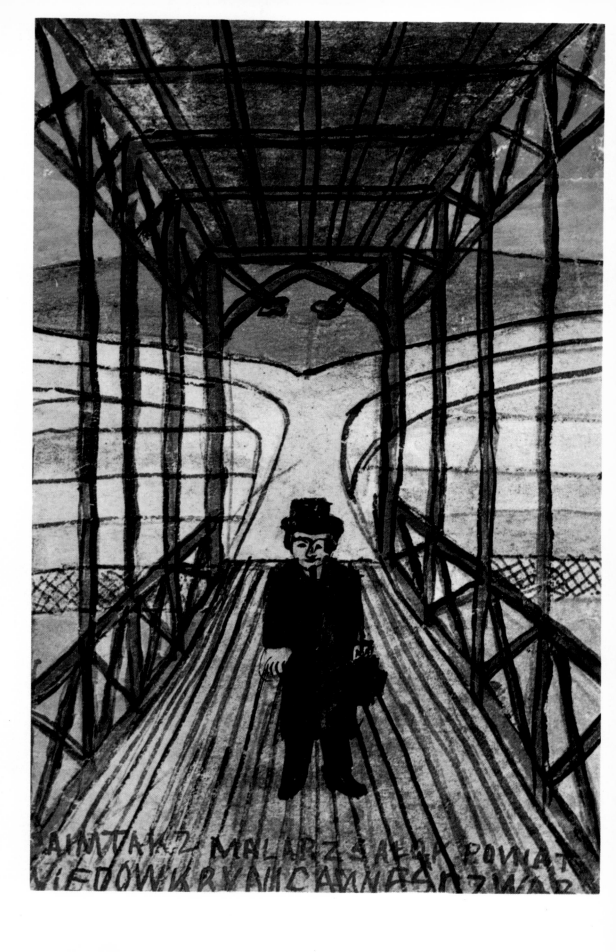

JOSEPH PICKETT (1848–1918)

21. *Manchester Valley, New Hope, Pennsylvania*

c.1914–1918. Oil with sand on canvas. $45\frac{1}{2} \times 60\frac{5}{8}$in. (115·5 × 155·5cm)

Joseph Pickett was born in the small American township of New Hope, and after some years of wandering, settled there until his death. His four extant paintings are loving records of the locality. Here, the landscape is built up in painstaking stages, the buildings growing in size as they occur further up on the canvas; the distant school-house bell is larger than the one close-to, a splendid example of a logic of emotion rather than of perception. The town and foreground trees have an orderly, 'just so' look, while the wind-tossed trees on the skyline and the queer gully on the left introduce an agitated note. Finally there is the train, eye-catching in its reds and greens. It seems to lollop into town like an ungainly animal intent on disturbing the peace and propriety.

New York, Museum of Modern Art

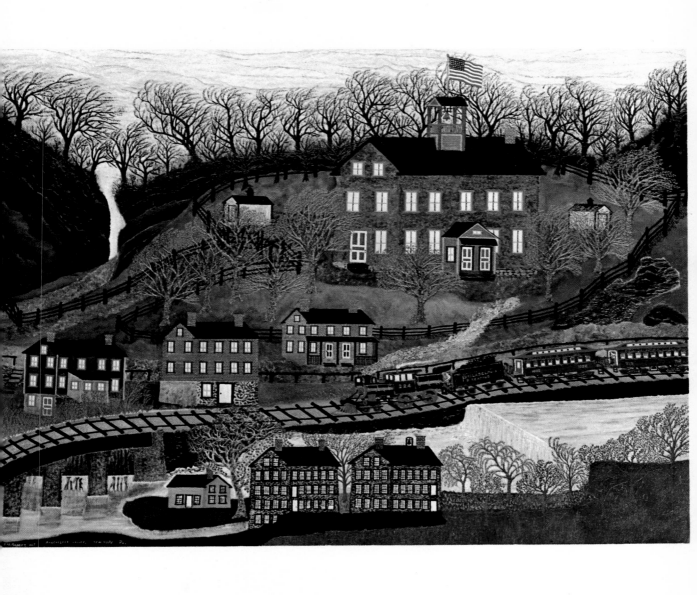

HORACE PIPPIN (1888–1946)

22. *John Brown going to his Hanging*

1942. Oil on canvas. 24 × 30in (61 × 76cm)

An American Negro of humble origin, Horace Pippin fought for the U.S. Army in France during the First World War. His paintings record real-life moments from his front-line experience, memories of childhood, landscapes, religious and historical events. Among the last is this exercise in 'fictional documentary' on the execution of the anti-slavery militant John Brown. The picture makes bold use of black and white contrasts and emotive reds splashed on the dark mass of the crowd. The sense is one of outrage expressed with high sobriety. Pippin proclaims his sympathies by signing his name below the superbly disdainful Negress in the corner.

Philadelphia, Pennsylvania Academy of the Fine Arts

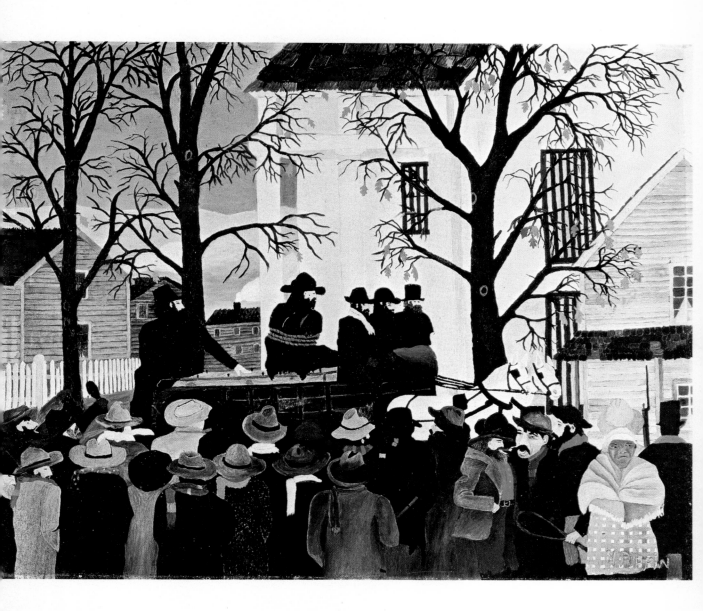

IVAN RABUZIN (b.1919)

23. *My World*

1962. Oil on canvas. 28 × 35½in (71 × 90cm)

One of the foremost naives of contemporary Yugoslavia,
Rabuzin draws his inspiration from the countryside about
his native village of Ključ. Reminiscences of his
childhood perception of the external world arise in his
paintings of local fields, woods and hills: we no longer
witness the empirical depiction of an objective reality,
but an intimate participation in landscape in which
subjective meaning is paramount. Here, the artist's
feelings are conveyed in metaphorical terms: his devotion
to his village is that of a gardener nursing rare blooms
in a pot.

Zagreb, Gallery of Primitive Art

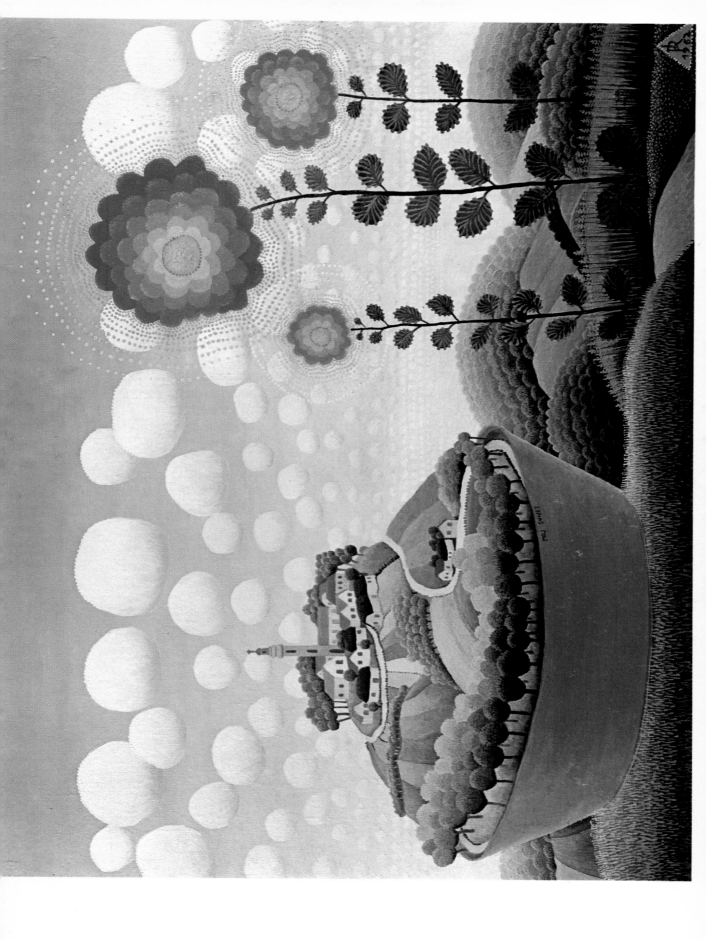

IVAN RABUZIN (b.1919)

24. *Bird-Catcher*

1962. Oil on canvas. 37 × 29¼in (94 × 74·5cm)

The peasant streak in Rabuzin comes out in this sympathetic portrait of a solid countrywoman clutching a wild bird (an owl?) in her fist and carrying a full basket of eggs (hen's eggs?) on her arm. Perhaps there is a hint of a sly joke in that the features on the bird's face are perfectly symmetrical, while those on the woman's are noticeably assymetrical.

Zagreb, Gallery of Primitive Art

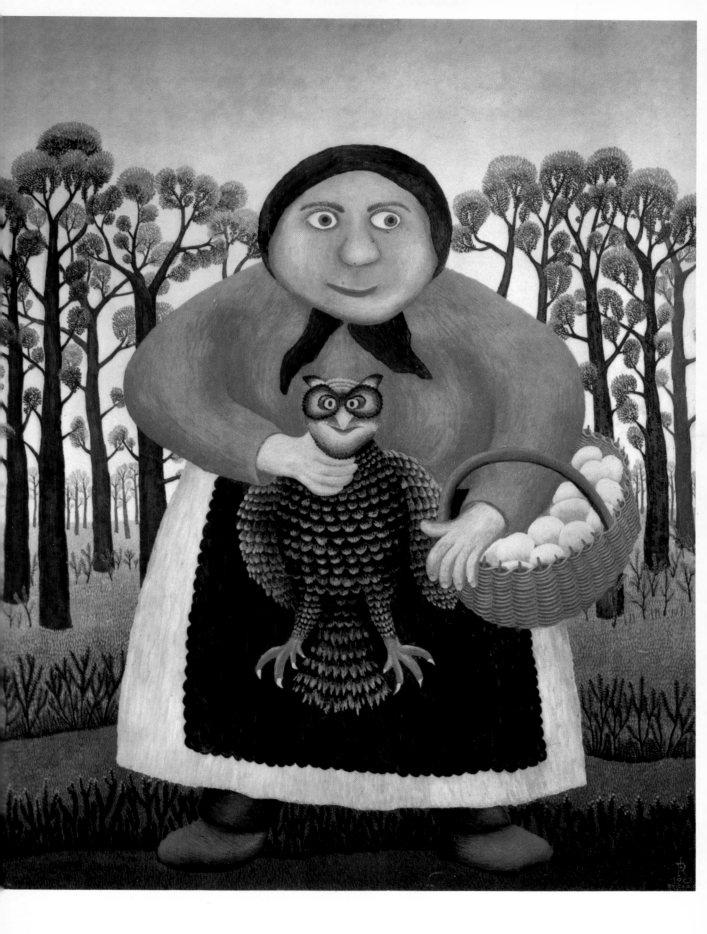

HENRI ROUSSEAU (1844–1910)

25. *The Toll Gate*

c.1895. Oil on canvas. $14\frac{3}{4} \times 12\frac{3}{4}$in (37·5 × 32·4cm)

Rousseau is both historically and artistically the outstanding modern primitive. After an undistinguished army career, he held a minor post in the Paris toll service (hence the patronizing nickname, 'Le Douanier', the Customs Officer). His duties took him all round the rural outskirts of Paris, and this simple view of his place of work shows his city-dweller's receptivity to the attractions of untouched nature. Ingenuous at first glance, the scene has some odd elements to it, in particular the studied groupings (1 spire, 2 men, 2 chimneys, 3 lamps, 4 trees), which suggest a hidden intention.

London, Courtauld Institute Galleries

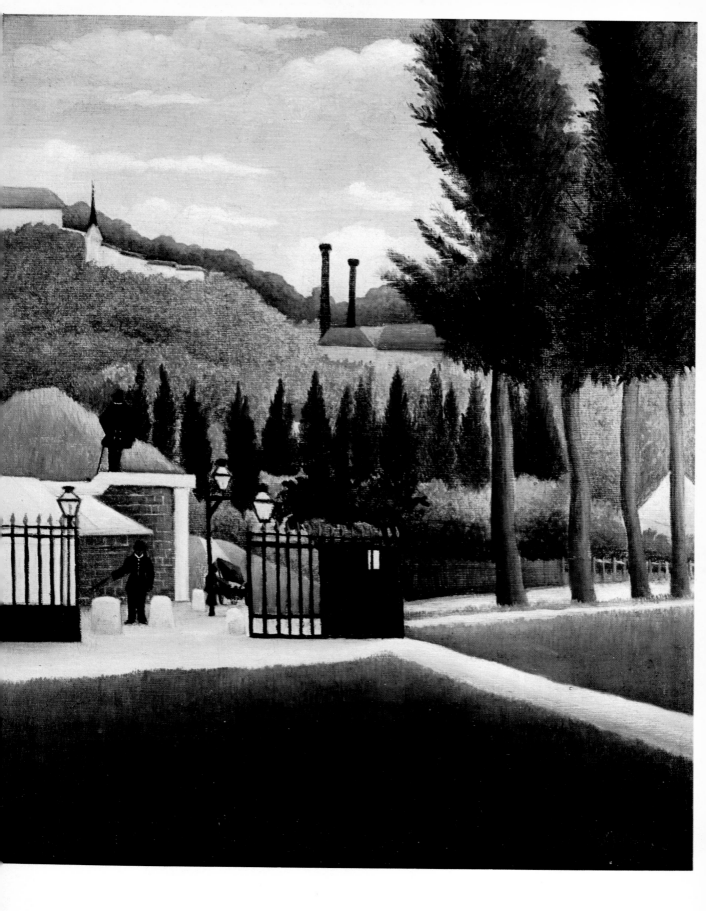

HENRI ROUSSEAU (1844–1910)

26. *Virgin Forest at Sunset (Negro attacked by a leopard)*

c.1907. Oil on canvas. $42\frac{1}{2} \times 67\frac{1}{2}$in ($108 \times 171\cdot5$cm)

It is likely that the story of Rousseau's stay in Mexico with the army is apocryphal, and that the tropical life which furnishes his most striking material is a mixture of pure fantasy and impressions of the Jardin des Plantes in Paris. This jungle image has an altogether unreal character, with its cut-out foliage and pasted-on sun and the uncontoured blackness of the man's body. The mood is theatrical and yet there is an arresting grandeur in this emblematic portrayal of a jungle which is not only cruel but also utterly airless and still.

Basel, Kunstmuseum

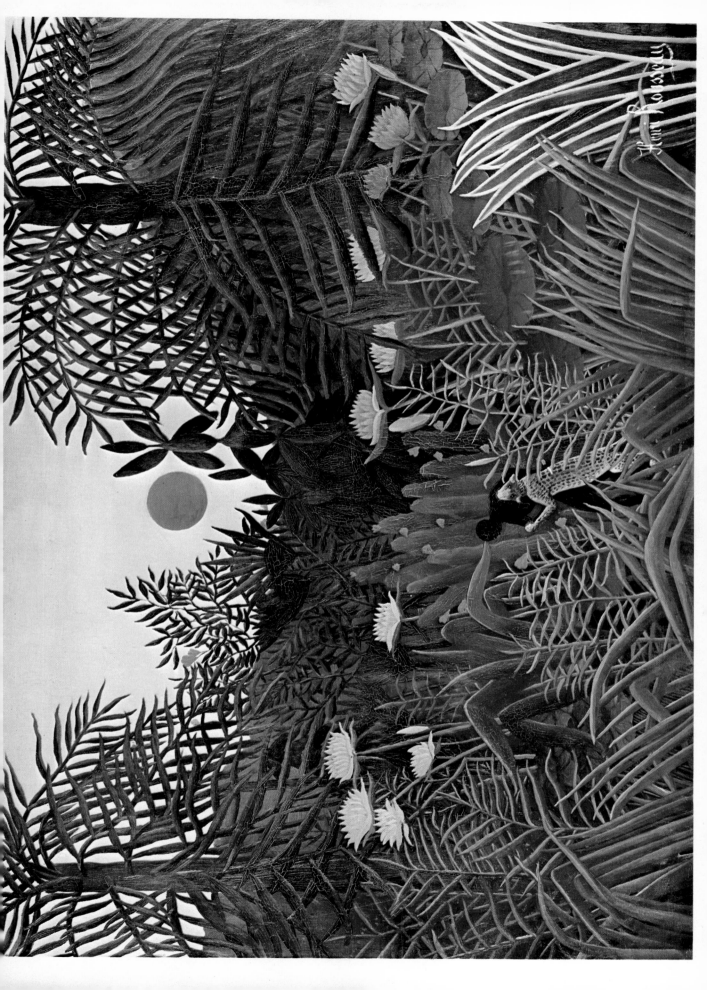

HENRI ROUSSEAU (1844–1910)

27. *The Tiger Hunt*

c.1895–1904. Oil on canvas

Rousseau exhibited stubbornly at the Salon des Indépendants for years, apparently impervious to public derision. In some respects, his work does court ridicule, as witness this rather feeble attempt to convey a sense of risk and noble adventure. Yet out of such secondhand material as a scene from some schoolboy adventure yarn, Rousseau extracts a strange poetry and mystery. The stiff figures in their pseudo-heroic poses exert a curious magnetism.

Ohio, Columbus Gallery of Fine Arts (Gift of Ferdinand Howald)

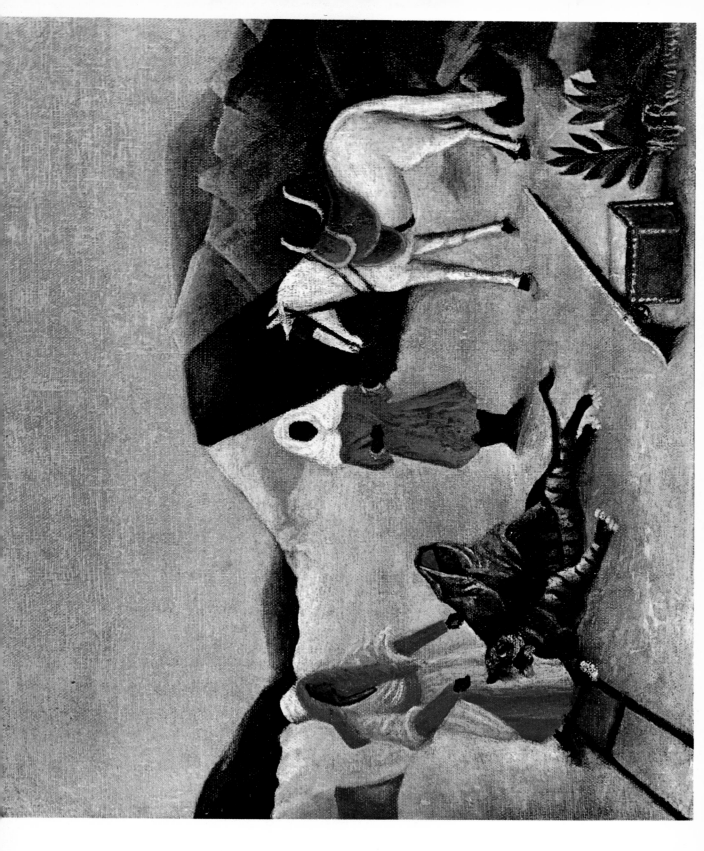

HENRI ROUSSEAU (1844–1910)

28. *The Dream*

1910. Oil on canvas. $80\frac{1}{2} \times 117\frac{1}{2}$in (204·5 ×298cm)

This is one of Rousseau's masterpieces and depicts the dream of Yadwiga, a Polish schoolteacher whom Rousseau had loved. She is transported in her dream (which is really Rousseau's) to a primeval forest packed full with fierce beasts which are held magically at bay by the snake-charmer's flute. The incongruity between the urbanity of the plush sofa and the savagery of its location runs parallel to the artist's own duality as a 'sophisticated primitive'. Such contraries are transcended as we pass from riddle to deep symbolism, and begin to see the image as representing the vacillation between chaste adoration and libidinous desire, between control and instinct.

New York, Museum of Modern Art (Gift of Nelson A. Rockefeller)

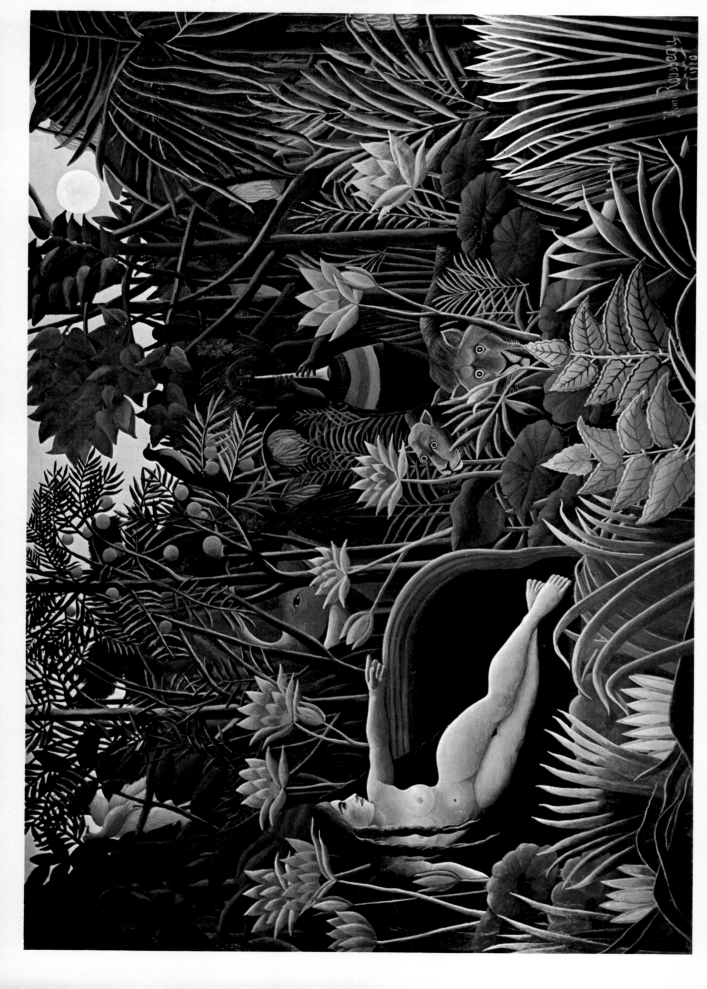

HENRI ROUSSEAU (1844–1910)

29. *In the Forest*

c.1886. Oil on canvas. $27\frac{1}{2} \times 23\frac{3}{4}$in (70 \times60·5cm)

Rousseau's best work arises from his preoccupation with the simultaneity of the exotic and the familiar. Here a city lady is set down in an untrodden forest. She seems scarcely to notice that she is not in her drawing-room, and simply waits for someone (her lover?) to appear. Although in other pictures Rousseau gives more dramatic expression to the meeting of the credible and the incredible, there is an exquisite confidence in this unassuming statement about the continuity of reality and daydream.

Zürich, Kunsthaus

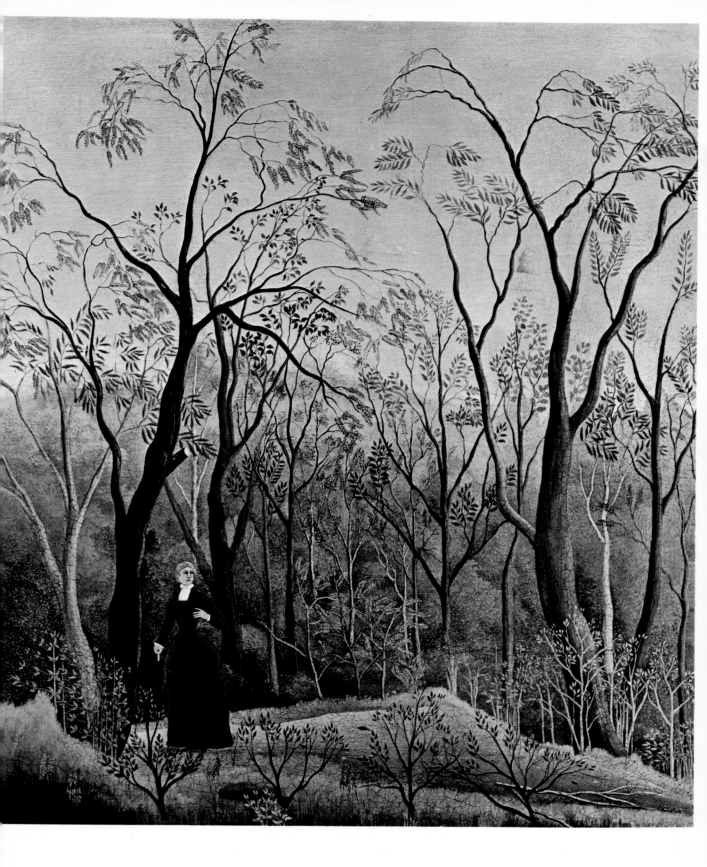

MATIJA SKURJENI (b.1898)

30. *I dreamt I was in Marseille*

1971. Oil on canvas. $51\frac{1}{4} \times 31\frac{1}{2}$in (130 × 80cm)

A former miner, railwayman and house painter, the
Yugoslav naive Matija Skurjeni began painting seriously
at the age of 48. His subject matter is the dreams he has
each night: the task of the brush is to catch their
fragile forms, to stabilize their rare colour and intensity
before the waking mind damages or suppresses them.
Here, a marvellous journey to a distant city is
documented with a meticulous clarity which denies any
sense of idle fancy.

Collection the Artist

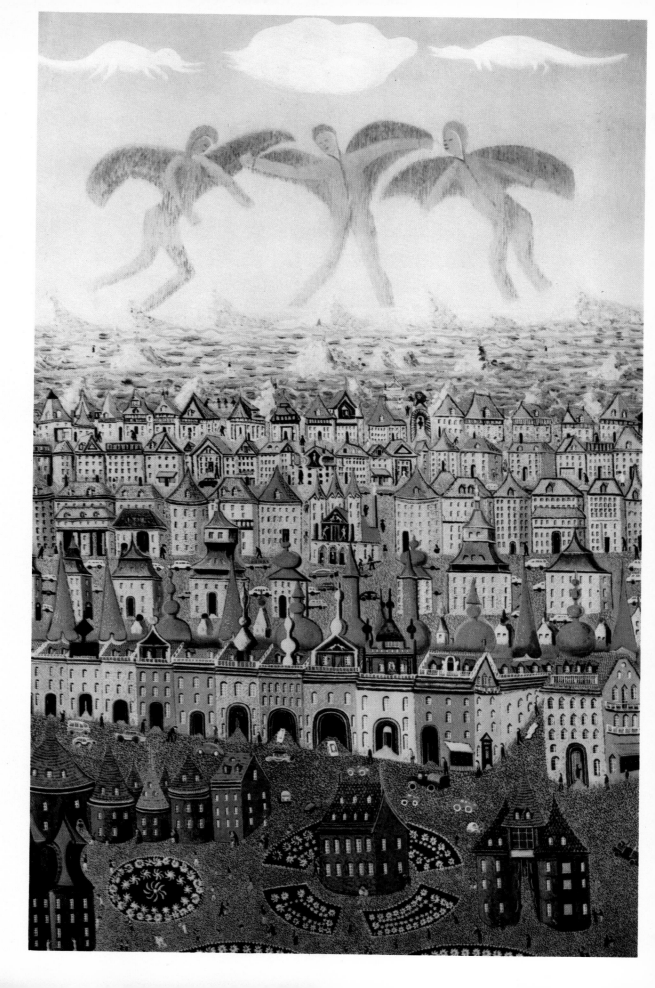

MATIJA SKURJENI (b.1898)

31. *The Acrobats*

1961. Oil on canvas. $23\frac{1}{2} \times 29in$ (60 ×74cm)

Here Skurjeni amazes us — and himself! — with a group
of figures whose relationships seem quirkily jarring. A
human figure concealed beneath a sheet, a flimsy chair,
a cockerel on a hoop, all are set down on a sloping gym
floor as in some cryptic nursery rhyme. The artist's
naive manner here encompasses a surreal poetry and
while the subject is focused in an intuitive way, there
seems nothing hesitant about Skurjeni's handling of the
riddle.

Paris, Radovan Ivsic Collection

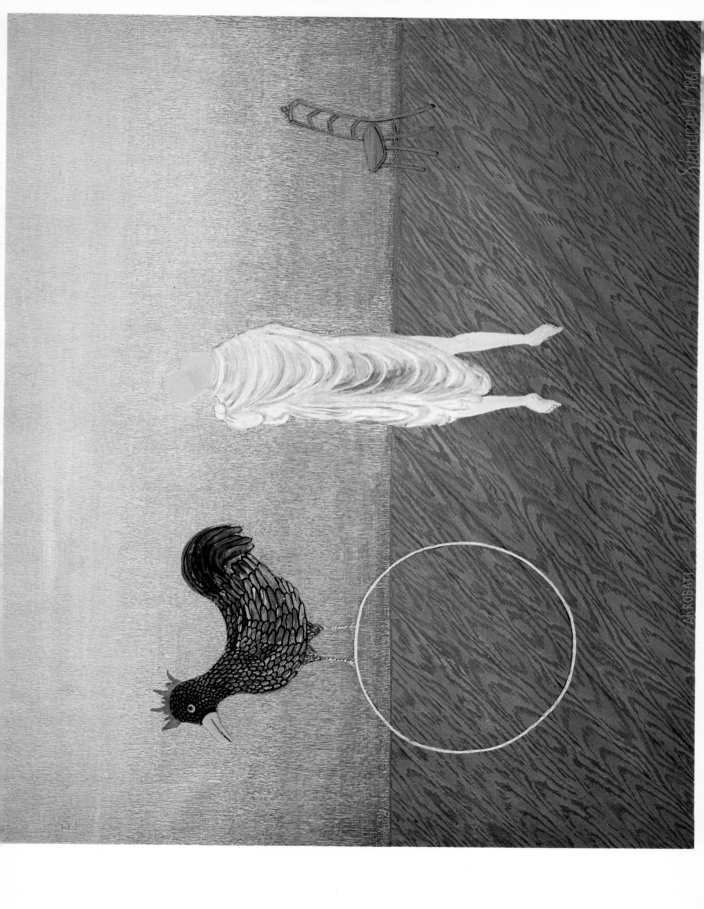

MATIJA SKURJENI (b. 1898)

32. *Gipsy Love in Moonlight*

1966. Oil on canvas. $29\frac{1}{2} \times 41\frac{1}{2}in$ (75 ×105cm)

Skurjeni's chaste lovers steal away along a woodland
path by moonlight; their tired old horse has been given
wings. The scene has a fragile magic, as if the painter
were able to stretch reality just so far — an inch further
and the charmed pathway will tear and pitch the lovers
into the darkness.

Novi Sad, Collection Dr Vojin Bašičević

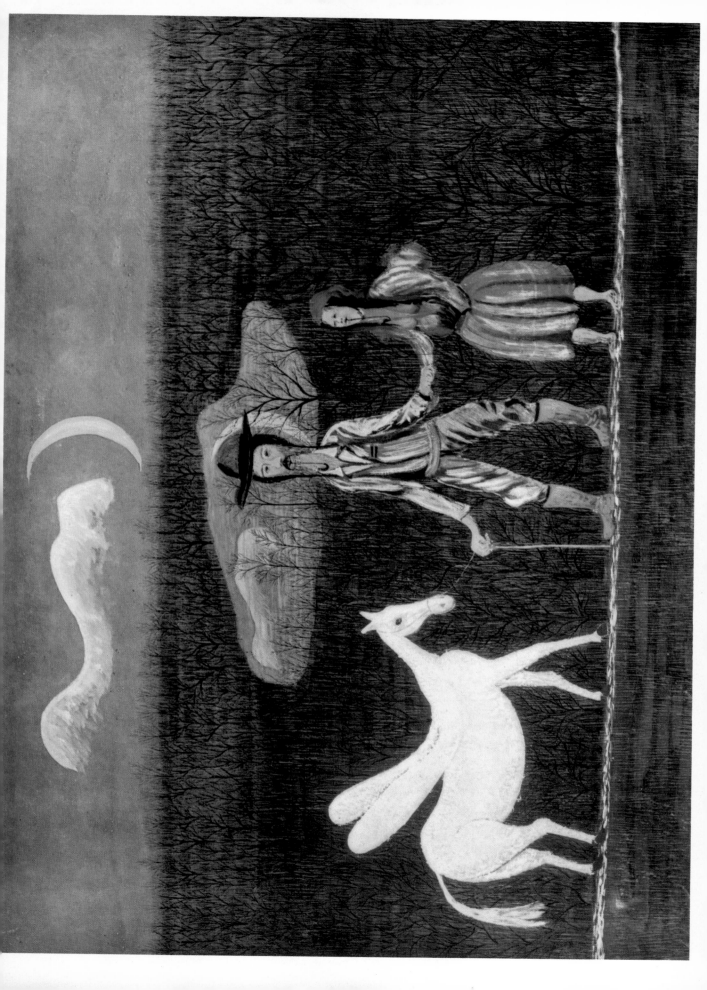

DROSSOS P. SKYLLAS (c.1900–c.1975)

33. *Three Sisters*

1960s. Oil on canvas. 58 × 39in (147 × 99cm)

A Greek-born immigrant to the United States, Drossos
P. Skyllas produced highly mannered paintings in which
naive traits co-exist with a style and subject matter
derived from popular imagery. This vision of three
glamour-girl Graces sporting voluptuously on a
travelogue beach, complete with fake roses and
improbable cloud formations, is an example of neo-
primitivism veering into sheer kitsch. The cute kitten and
the superbly ugly bulldog underline the impression that
the artist is revelling in bad taste for its own sake.

Chicago, Phyllis Kind Gallery

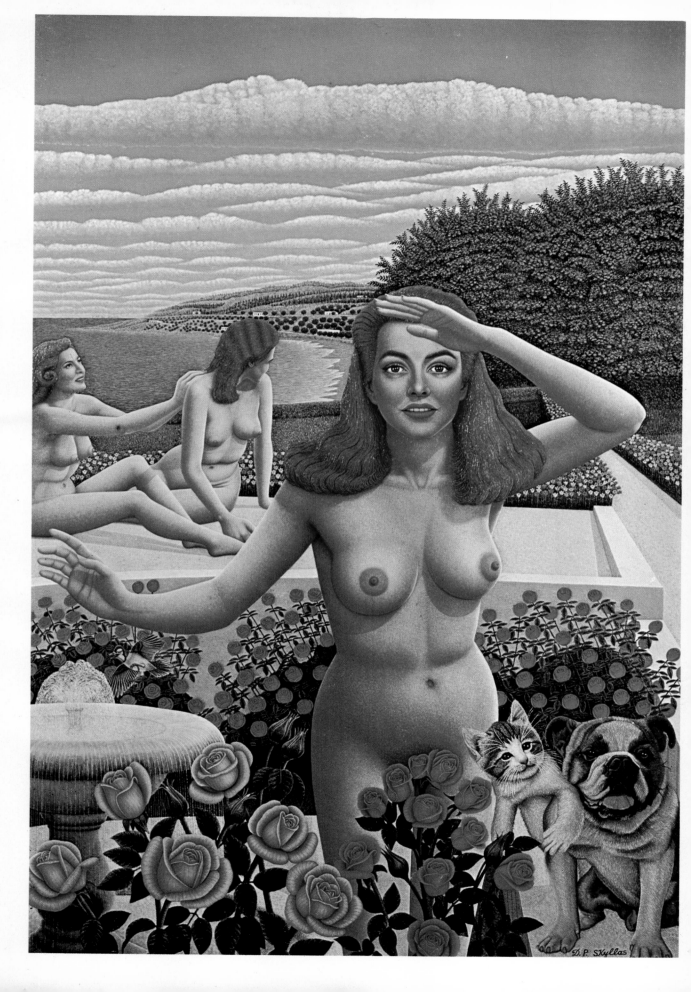

DROSSOS P. SKYLLAS (c.1900–c.1975)

34. *Lake in the Hill and Icicles*

1950s. Oil on canvas. 30 × 36in (76 × 91·5cm)

Here Skyllas offers a peepshow view of a landscape
reduced to an austere minimum. Most of what we see —
the stone blocks which frame the vista, the earth, the
mountains — seems to be composed of the same undefined
substance, half-rock, half-ice. What remains is fir trees
and icicles, their sharp points jutting towards one
another in a vaguely menacing way. The impression is
of a stillness so stark as to be unnerving: no emotion can
be projected into this glittering, inert world.

Chicago, Phyllis Kind Gallery

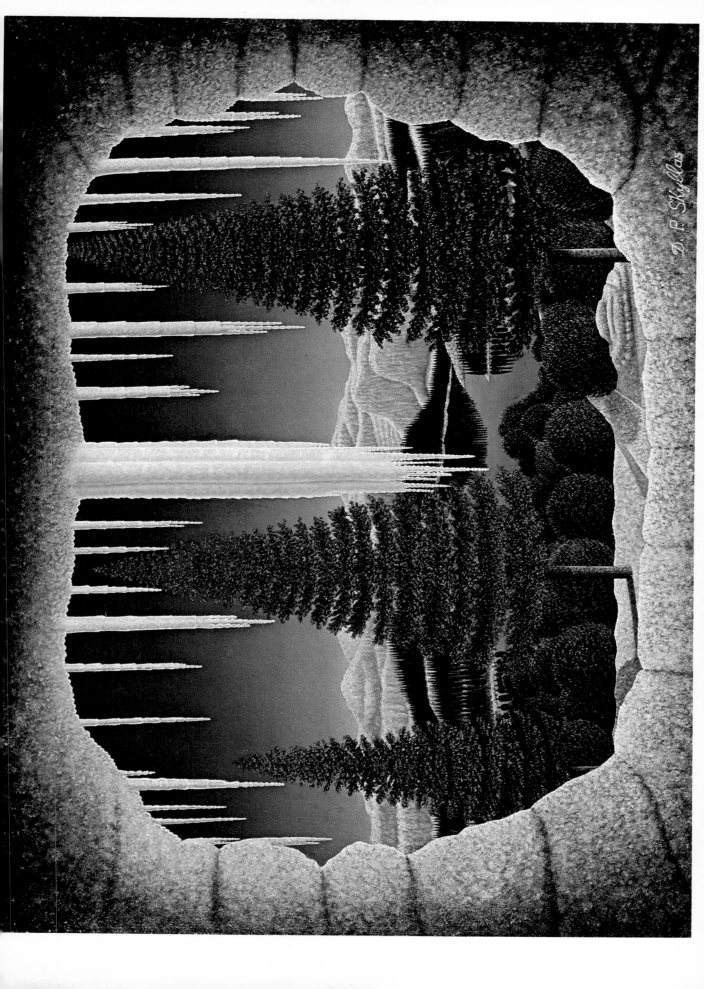

JOSEPH SLEEP (b.1914)

35. *Cat*

1975. Acrylic on paper. 30 × 22in (76 × 55·5cm)

A former New Brunswick fisherman and Jack of all trades for a Canadian circus, Joe Sleep began painting at the age of 59 during a spell in hospital. His picture is a somewhat 'inarticulate' rendering of a cat's body and the fur looks as if it has been knitted, but the image as a visual unit makes a striking and solemn impact.

Halifax, Nova Scotia College of Art and Design

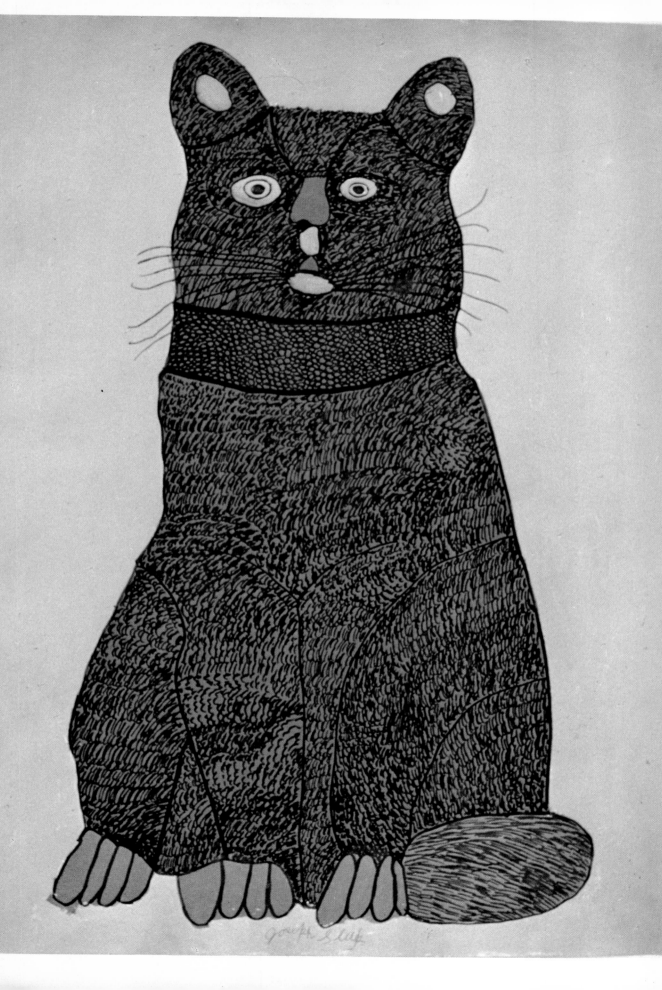

Joseph Slelf

ALFRED WALLIS (1855–1942)

36. *Penzance Harbour*

Oil and pencil on card. 12 × 18in (30·5 × 45·5cm)

Wallis was an ex-fisherman who took up painting 'for company' after his wife's death, when he was nearly 70. His home town of St Ives in Cornwall is a popular spot for professional and amateur painters, but Wallis ignored all influences and devoted himself to resolutely primitive images of Cornish houses, harbours and ships, setting down a catalogue of observations and memories on improvised scraps of wood and cardboard.

Cambridge, Kettle's Yard (University of Cambridge)

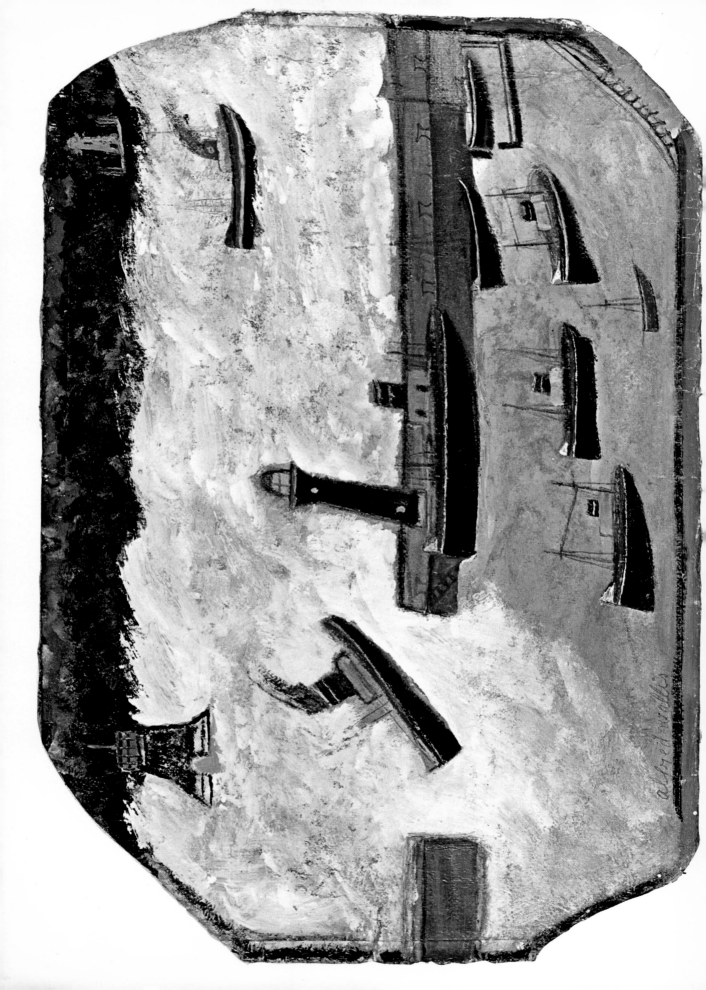

ALFRED WALLIS (1855–1942)

37. *Houses in St Ives*

c.1930. Oil and pencil on card. $10\frac{1}{8} \times 15\frac{1}{8}in$
(25·5 ×38·5cm)

This 'mind's eye' view of old St Ives with its curving streets and topsy-turvy houses exemplifies the vigour and spontaneity of the best of Wallis's work.

London, Tate Gallery

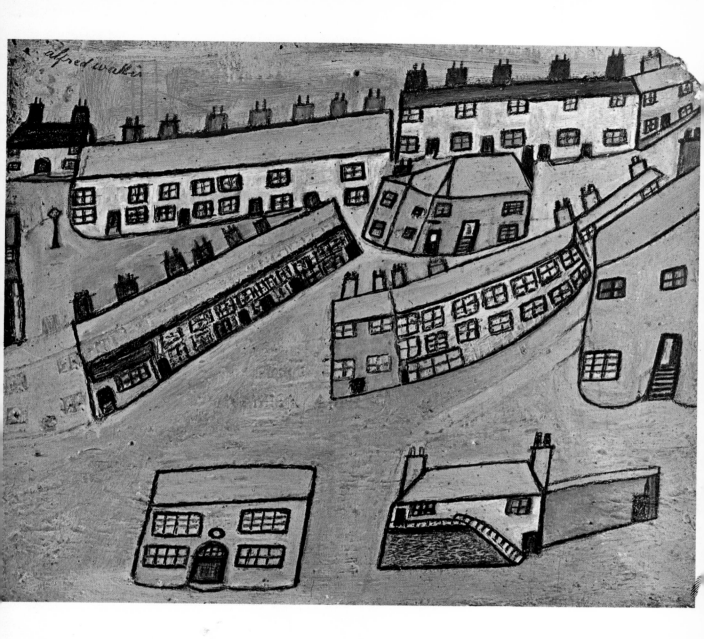

ELLEN WANG (b.1947)

38. *Dreaming by the Paraffin-Lamp*

1975. Pastel and ink on silk. 19 × 16½in (48 × 41·5cm)

Ellen Wang's pictorial world recaptures the savour of a childhood spent amid the lonely mountains, fjords and spruce forests of Norway. This image explores the trance-like experience of being absorbed in contemplation of a bright lamp, whose glowing shape swells in the darkness and conjures up an unexplained tracery of black lines. Within the little compartments tiny forms wriggle into focus: insects, birds, shrubs, huts and a haunting blue eye reminiscent of the one in Séraphine Louis' *The Tree of Paradise* (plate 18).

Oxford, Collection the Artist

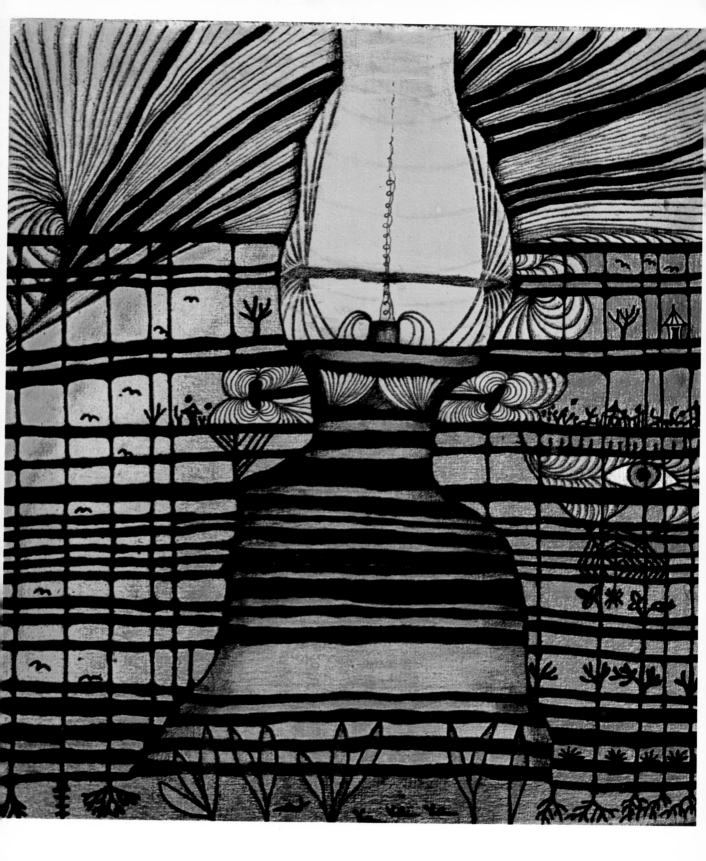

SCOTTIE WILSON (1890–1972)

39. *Birds below a Flower*

*c. 1955. Felt pen and poster paint on black card. 12 × 9½in
(30½ × 24cm)*

The main body of Scottie Wilson's work reveals a
steadfast commitment to strangeness, and consists
largely of grotesque self-portraits and savagely deformed
figures. It should undoubtedly be seen as Art Brut. His
later work, however, modulated into a far less aggressive
and eccentric style, exemplified by this tender and
decorative image. The horizontal wavy lines of the sky
and the ground complement the vertical line of the
flower-stalk, while the yellow disc at the heart of the
flamboyant petals echoes the sun above. The birds,
epitomizing vulnerability and uncertainty, rest at peace
in the shelter of the protective plant.

London, Fieldborne Galleries

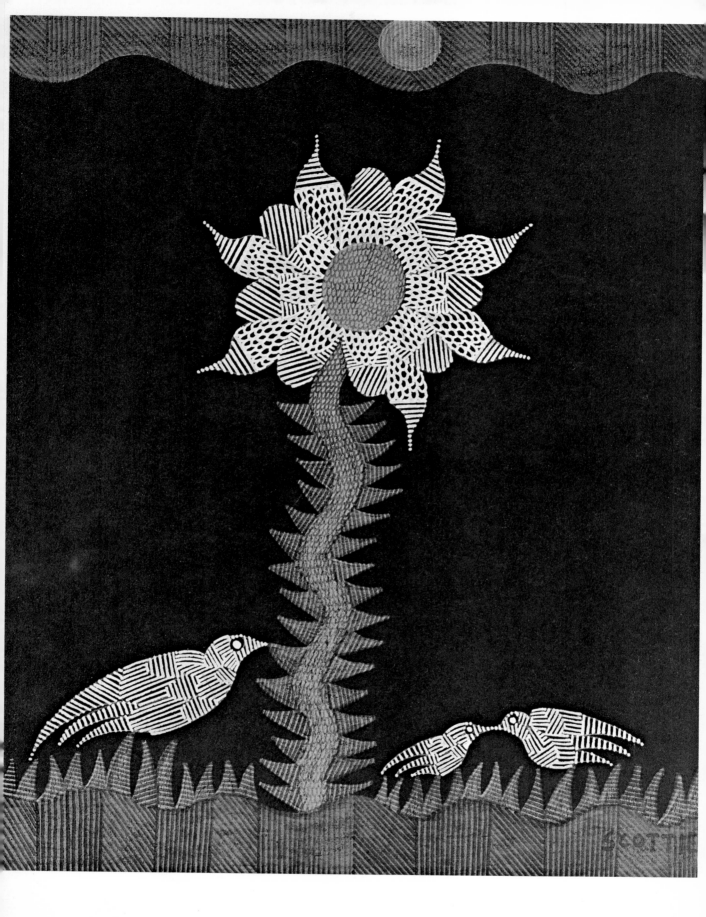

ALOYS ZÖTL (before 1831–after 1887)

40. *The Sloth*

1840. Watercolour

No biographical information has ever come to light
concerning the dyer Aloys Zötl from Upper Austria, save
that over the period 1831–87 he produced dozens of
watercolours depicting animal species. This intriguing
bestiary, almost certainly prompted by book illustrations
rather than direct observation, reveals an eager fantasy
at work, and a delight in the abstruse and the monstrous.
Prefiguring certain aspects of Rousseau, such scenes
as this evocation of the sloth in its exotic habitat
produce an ambiguous effect of mingled eeriness and
harmony.

Paris, Collection Mme Elisa Breton

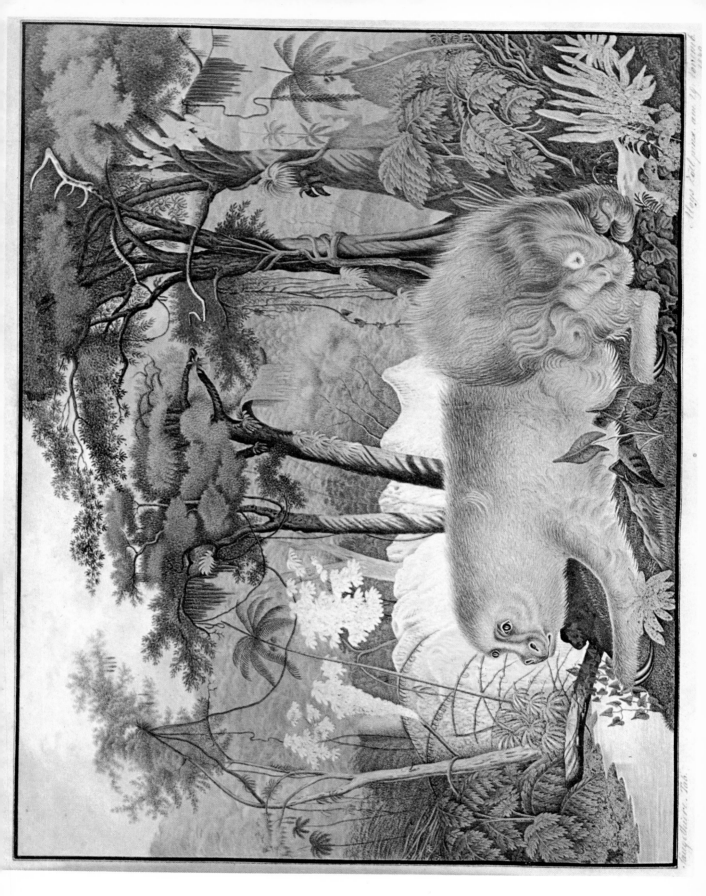

Acknowledgements, and list of illustrations and sources

THE AUTHOR AND BLACKER CALMANN COOPER LTD would like to thank the museums and owners who allowed works in their collections to be reproduced in this book. The author and Blacker Calmann Cooper Ltd would also like to thank the photographers and photographic agencies who provided transparencies.

1. Anonymous, *The Cat* — Edgar W. and Bernice C. Garbisch Collection, Washington DC. Photo National Gallery of Art, Washington DC
2. Anonymous, *The Death of McPherson before Atlanta* — David David Inc, Philadelphia
3. Franz Beck, *The Council Fire* — David David Inc, Philadelphia
4. Camille Bombois, *Wrestlers in the camp* — Perls Galleries, New York
5. Thomas Chambers, *Niagara Falls* — Wadsworth Atheneum, Hartford, Connecticut
6. Ernst Damitz, *Bayard Taylor's Midnight Sun in Lapland, Norway, Europe* — Courtesy of the Art Institute of Chicago
7. Adolf Dietrich, *Girl with striped apron* — Kunsthaus, Zürich
8. Emerik Feješ, *Milan Cathedral* — Gallery of Primitive Art, Zagreb
9. Ivan Generalić, *Crucified Rooster* — Gallery of Primitive Art, Zagreb
10. Ivan Generalić, *The Wedding of the Deer* — Collection of Josip Generalić, Zagreb
11. Steve Harley, *Wallowa Lake* — Abby Aldrich Rockefeller Folk Art Collection, Williamsburg, Virginia
12. Edward Hicks, *The Peaceable Kingdom* — Abby Aldrich Rockefeller Folk Art Collection, Williamsburg, Virginia
13. Morris Hirshfield, *Girl with Pigeons* — Museum of Modern Art, New York
14. Morris Hirshfield, *Girl with Dog* — Collection of Edward A. Bragaline, New York. Photo Ricci Editore, Milan
15. John Kane, *Self-Portrait* — Museum of Modern Art, New York
16. Henry Kip, *Attack by Bears* — The American Museum in Britain, Bath
17. Jules Lefranc, *The Eiffel Tower* — Centre National d'Art et de Culture Georges Pompidou, Paris
18. Séraphine Louis, *The Tree of Paradise* — Centre National d'Art et de Culture Georges Pompidou, Paris. Photo Jacqueline Hyde, Paris
19. Harvey McInnes, *Foothill Country* — Collection of D. & V. Thauberger, Regina, Saskatchewan
20. Nikifor, *Nikifor on his way* — Museum of Modern Art, New York
21. Joseph Pickett, *Manchester Valley* — Courtesy Pennsylvania Academy of the Fine Arts, Philadelphia
22. Horace Pippin, *John Brown going to his Hanging* — Gallery of Primitive Art, Zagreb
23. Ivan Rabuzin, *My World* — Gallery of Primitive Art, Zagreb
24. Ivan Rabuzin, *Bird Catcher* — Courtauld Institute Galleries, London
25. Henri Rousseau, *The Toll Gate* — Kunstmuseum, Basel. Photo Hans Hinz
26. Henri Rousseau, *Virgin Forest at Sunset* — Columbus Gallery of Fine Arts, Ohio
27. Henri Rousseau, *The Tiger Hunt* — Museum of Modern Art, New York
28. Henri Rousseau, *The Dream* — Kunsthaus, Zürich
29. Henri Rousseau, *In the Forest* — Collection of the Artist
30. Matija Skurjeni, *I dreamt that I was in Marseille* — Radovan Ivsic Collection, Paris
31. Matija Skurjeni, *The Acrobats* — Collection of Dr Vojin Bašičević, Novi Sad
32. Matija Skurjeni, *Gipsy Love in Moonlight* — Phyllis Kind Gallery, Chicago
33. Drossos P. Skyllas, *Three Sisters* — Phyllis Kind Gallery, Chicago
34. Drossos P. Skyllas, *Lake in the Hill and Icicles* — Nova Scotia College of Art and Design, Halifax. Photo Peter Sheppard
35. Joseph Sleep, *Cat* — Kettle's Yard, Cambridge
36. Alfred Wallis, *Penzance Harbour* — Tate Gallery, London. Photo John Webb
37. Alfred Wallis, *Houses in St Ives* — Collection of the Artist, Oxford
38. Ellen Wang, *Dreaming by the Paraffin-Lamp* — Fieldborne Galleries, London. Photo Freeman
39. Scottie Wilson, *Birds below a flower* — Collection of Mme Elisa Breton, Paris. Photo Ricci Editore, Milan
40. Aloys Zötl, *The Sloth*